DINERS

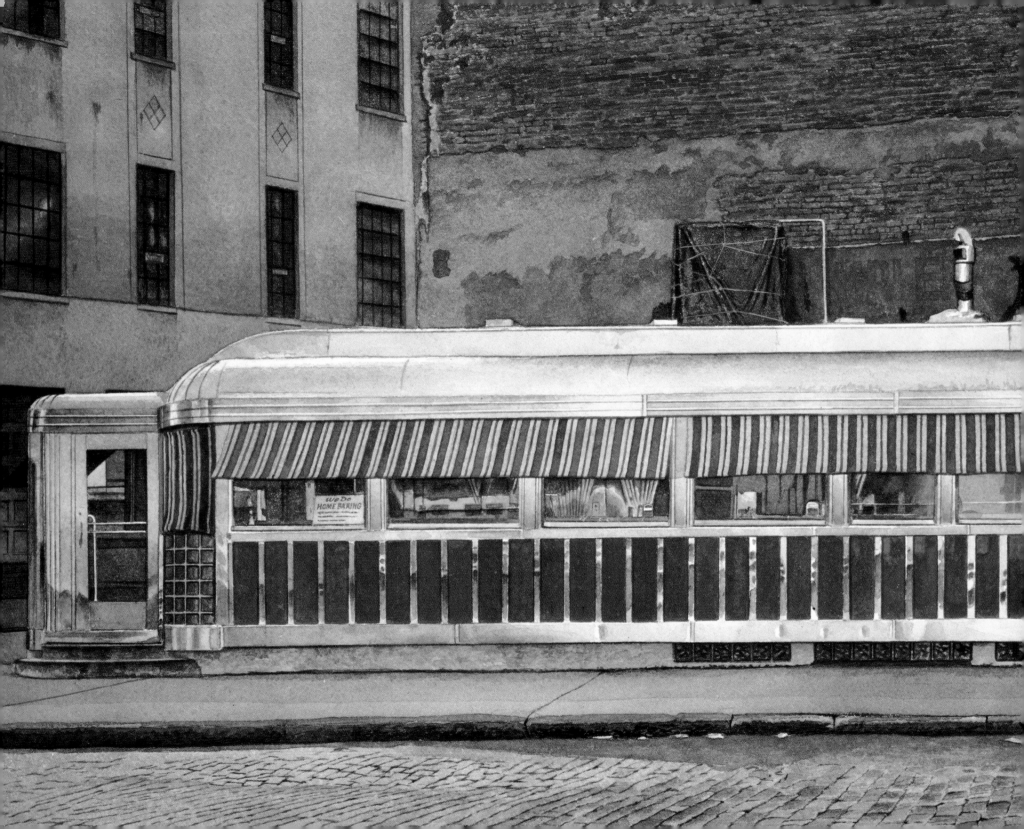

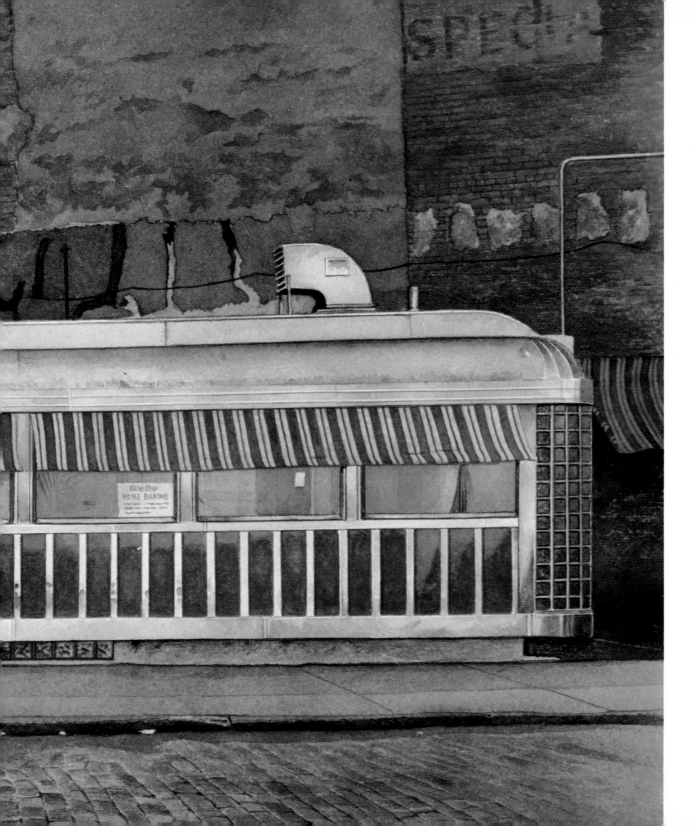

Introduction by
Vincent Scully

DINERS
by John Baeder

Harry N. Abrams, Inc.
Publishers, New York

For Rivian and Julius

Editor: Walton Rawls

Library of Congress Cataloging in Publication Data
Baeder, John.
 Diners.
 1. Baeder, John. 2. Diners (Restaurants) in art.
I. Title.
ND237.B215A44 759.13 77-13203
ISBN 0-8109-2078-6

Library of Congress Catalogue Card Number: 77-13203
Illustrations copyright © 1978 by John Baeder, New York
Published in 1978 by Harry N. Abrams, Incorporated, New York

Printed and bound in Japan

veryone we know affects us in one way or another, some people more directly than others. I thank them all.

Special gratitude goes to my good friend and fellow diner maniac Richard J. S. Gutman, *the* authority and only scholar in the field of diners. We spent much time together talking, traveling, and loving diners, and he suggested many of the diners I have painted. I am deeply indebted to him. Heartfelt thanks go to Jackie Goldenberg for sharing her sensibilities (and peppers). Her keen intelligence, perception, and wit have been inspirational, but, most of all, I thank Jackie for lighting the fires that brought forth the beginning words. And sincere appreciation goes to Steve Heller, who believed with me that my paintings could find a wider audience in book form.

I also would also like to thank Joan Oettinger Baeder, who gave me the initial boost to painting; Richard Steinberg, for his many supportive words of wisdom; John Kacere, for his early recognition; my dealer Ivan Karp, for his foresight; Jim and Myra Morgan of the Morgan Gallery in Shawnee Mission, Kansas, for introducing dinerdom to the Midwest; Marna Anderson, Barbara Bascove, Anne Browne, Jill Paulk, and Matthew Harris, for their patience, caring, and listening during many crucial moments; Sarah Jane Freymann, for her perseverance and belief; and my good friend (and sister) Margot Weinshenker, who gave me the freedom of her house to put together the manuscript and provided a plenitude of my favorite pickles.

Also, I want to thank the following for their friendship and continued interest and help: Robert Venturi, Denise Scott-Brown, Steve Izenour, and Paul Hirshorn of Venturi and Rauch Architects and Planners in Philadelphia; DeForrest Jackson of the Coca-Cola Company in Atlanta; and Harry Lowe of The National Collection of Fine Arts in Washington.

In addition, I'm grateful to the following photographers: Bruce Jones, Centerport, N.Y.; John Lowrey, Kansas City, Mo.; Arnold Rosenberg, New York, N.Y.; Eric Pollitzer, New York, N.Y.; Dennis McWaters, Richmond, Va.; Transparencies Inc., New York, N.Y.; and Malcolm Varon, New York, N.Y.

And finally I must thank my editor Walton Rawls for his extreme patience and understanding, but most of all for his expertise and sensitivity—and knowing how to tell me tactfully when to stop.

John Baeder
New York City

UNCLE WALLY'S
Watercolor, 13 × 18 1/2", 1977
Harvey Schulman Collection, New York

*Some diners remind me of large jeweled
sculptures; others are like temples dug up from
ancient civilizations. (Can you imagine the
King Tut Diner?) "Uncle Wally's" in Matamoras,
Pennsylvania, is one of these spectaculars. I ran
across Uncle Wally's five years ago (when it was
just the Matamoras Diner). Often I push my
limits and return to diners that haunt me. I
traveled two and a half hours to rediscover this
one, and I remembered how it glistened from
inside and out. No matter how the light was
shining, it remained bright and radiant, like
an ad for silver polish.*

 *The Paramount Dining Car Company
manufactured this beauty. The circular design
motif on the paneling was used only by
Paramount. I couldn't figure out why they went
through this grandiose effort to decorate their
diners. Most of them are gone forever, or masked
by a new brick facade. I saw one recently that
seemed to be embarrassed by its corner glass
brick; to hide the glass the owners had wrapped
sheet aluminum around the corner. It was like
a permanent makeup job that didn't just cover
up age and character but repressed a vital
emotion.*

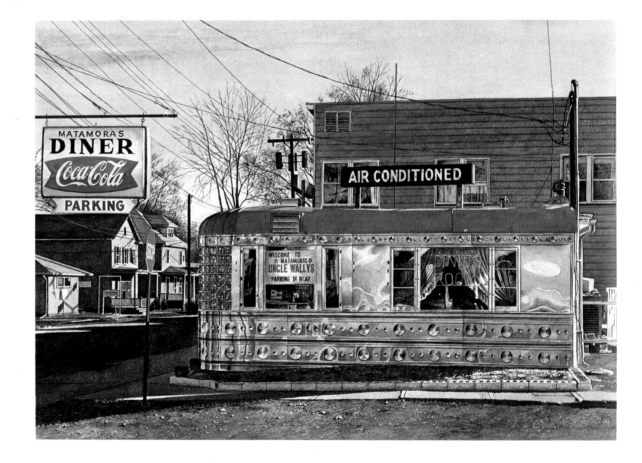

John Baeder's paintings seem to me to differ from most of those of his brilliant Magic-Realist contemporaries in that they are gentle, lyrical, and deeply in love with their subjects. Most of the painters of the contemporary Pop scene blow our minds with massive disjunctions, explosive changes of scale, and a special kind of winkless visual focus. Baeder does not employ any of those devices. He sees everything at its own size in its proper environment. His Diners fit into their urban context like modest folk heroes. Baeder is always painting a whole place. His light plays a large part in that integration of everything. It, too, is usually gentle, but it is most of all varied and always has a source. Sometimes it is a rich, late afternoon glow with long shadows, sometimes a hot noontime blare. If there is a dull tone with no shadings it is because a gray day's atmosphere is being made to suffuse the whole. There are night scenes. The electric light is no less lovingly painted than the sun. Because of all this, one tends to think of Baeder as a traditional colorist. He is painting landscapes not merely unified but modulated by light. Because of this, too, his work has dimensions which many of his contemporaries avoid. It is full of a sense of time, including the time of history. Sloan and other Ashcan School painters may be consciously cited, as in the dusky shapes beside the Empire Diner. Hopper is felt everywhere; it is a lyricism similar to his own that calls him up. But Baeder is not haunted like Hopper by a sense of something empty, hollow, and solitary in the American experience. Instead, he is youthful, hopeful, a painter-poet who makes us see the beauty of common things—not how funny they are, or how disgusting, or how powerfully expressive even, or how frightening, or just how big—but how lovely, how seen with love. Baeder writes the same way.

We can thank our luck that human life and art constantly escape from the models we construct for them. My generation excluded the vulgar Pop world, emphatically including that of the Diner, from our consideration and, by precept, from that of our children—who then grew up and took it over and wove their fantasies into it and humanized it and made it art.

That is what Baeder has done. He is entirely at home in his world, and he irradiates it with the light of his intelligence and with what comes through as the sweetness of his soul.

Vincent Scully

The Col. John Trumbull
Professor of the History of Art
Yale University, 1977

lot of people ask me why I paint diners. It's a question I've never had to ask myself. I want to preserve diners. I love them. And I express this passion in the best way I know, by painting them.

My earliest awareness of diners came during World War II; it was 1944, and I was five years old. I lived with my parents and sister and grandparents (who came over from Budapest in 1938) in the Biltmore Hotel in Atlanta, Georgia. Homes were difficult to purchase in those days; we rented a couple, and when the leases were up we landed in the hotel. It was fun: instead of going up the usual few steps to the kitchen door at home, I would climb a double flight of long marble stairs into a huge lobby, which was our entrance hall. (I still love to sit in hotel lobbies.) My sister and I had a couple of rooms adjoining my parents' rooms; my grandparents were downstairs a few floors. I grew to love my grandparents dearly, and I got to understand some Hungarian as they were beginning to understand English.

Our rooms didn't come equipped with a kitchen, so we had our meals in the coffee shop, and occasionally in the main dining room. I can still taste those soggy, toasted sliced-chicken sandwiches. The smell of the yellow mayonnaise. Those colorful yellow-and-blue-and-orange-cellophane-entwined toothpicks stuck so deliberately atop the sandwich; they never held it together. Coffee-shop decoration. And that rancid green pickle. Not very fulfilling—sandwiches, a la king, hash, and all that. Sometimes we would all jaunt across the street to the marvelous Majestic Diner for a refill.

We sat at the counter; it was more intimate, and there were no booths. Since the counter was low and the stools were small, I could feel bigger than I was and see what was going on. We ordered hamburgers and fries (what else?). Without our asking, the burgers came with lettuce and tomato and mayo (Southern style), and I loved the whole mess.

I watched intently as the short-order chef went through his ballet routine of preparing meals. He'd open the big, shiny metal door of the refrigerator and take out hamburger patties, peel off the paper, and throw the red blob of meat on the grill. Sizzle. Down went the spatula. Flip; there went the buns on the searing grill. Another spatula press. A louder sizzzzzzle. Up came the fries, twist went the basket, swoosh went the plate. A twist of the body and they were on the counter. Clunk. I stared at the garnishing with mayo, lettuce, tomato—admired all the dexterity. More choreography and back to the shiny metal doors: the large, chromey, curvilinear hinges on the door; I loved just looking at them. The door made such great sounds: click, thud; click, thud.

A symphony concert of childhood, and the first moments of diner-mania. As I munched away I studied the starchy white shirt, and the

grease-spattered and -wiped apron. The white "soldier's" cap slanting toward the right ear; always the same slant, no matter who's wearing it. Short-order style. Behind-the-counter fashion. Unnoticed except by this five-year-old. Oh, those Camel-stained fingers, and the faded blue panther on his arm with blood dripping from its claws. He lays the cigarette on the edge of the counter. The malt, yes, here it comes out from under the green whizzer. And the BLT, square and toasted; swish, four dainty triangles. And the chocolate cream pie the Majestic was so famous for. Taste buds turned around: the early beginnings of diner palate.

I couldn't wait to go back to the Majestic. I didn't like the coffee shop or the dining room anymore, where I couldn't see what was going on. I needed repeat performances, not more food.

My second major diner experience was equally exciting, and the one not to be missed. At the time it seemed like just another childhood thrill, not a prescience of what was beginning to insinuate itself into my psyche for twenty-five years. Every summer after school closed my parents, sister, and I would take the train (the Louisville and Nashville) from Atlanta and visit my mother's father, and her brother and sister, in South Bend, Indiana. Family month. First stop: Chicago, and I can still smell those trains, especially the drawing room we all occupied.

In the middle of the night the train would stop. Back up. Go forward. Sit around. And then there was this huge jolt. My sister Margot and I were trying to sleep in the upper berth; boy, that clunk felt good. The reason for all this fun-filled mystery was the dining car being added to the train so that passengers could be fed on the way to Chicago next morning.

I could never stand waiting in line (and still can't), but we had to queue up for the dining car—first come first served. I'd get restless, with the throngs of people overbearing tiny me. My father knew I wanted to get out of line and look out the window, so he managed to find me a window to wait at. The entire trip my head was glued to the window. The window was a frame, and I was able to get my full share of visuals; my first real intake of visuals. This went on for several trips.

I cherished looking out the window at all those small-town backsides —the angle of my vision gave me some sense of power and freedom: newfound values. And there was the railroad crossing. I'd watch the stopped cars, and listen: Ding; Ding; Ding; Ding; Ding; Ding; and the marvelous muffled sound of a railroad crossing. I had a giant's view of a tiny slice of life, whizzing by like picture-seconds. Like going through a magazine picture after picture after picture after picture. . . . I couldn't get enough, although I *was* bored with the countryside. I guess it was the lack of textures and mixtures of colors and patterns. I looked for them, but I found greens on greens on greens. And the hypnotic telephone poles, they always interrupted my vision.

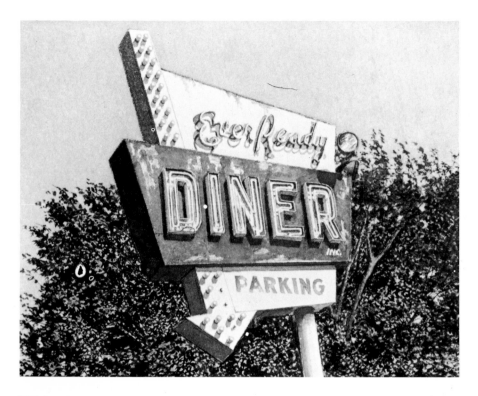

EVER READY
*Watercolor, 6 1/2 × 8", 1974. Courtesy Morgan
Gallery Shawnee Mission, Kansas*

MAJESTIC, *Watercolor, 14 × 20", 1977
Ronald D. Balser Collection, Atlanta, Georgia*

*After fifteen years, I returned to the Majestic in
Atlanta. It was the same; as with all diners, it
says what it is and nothing more. I was eagerly
looking forward to the return with my childhood-
adolescent-teenage-collegepunk-young-adult friend
Ron Balser. He was out of town, so our timing
was off. I wanted to rehash all the time we had
spent there.*

*So I made the visit with another old and dear
friend, De Jackson. We walked in, sat at the
counter, talked and watched. I was telling De
about my earlier experiences at the Majestic, and
how after all these years I had come full circle. I
was stepping back to that five-year-old and I got
involved with the counterman's choreography.*

*I looked around at the same green walls. My
favorite green of all greens: institutional green.
Landlord Green. Dull, flat, lazy green. At ease
easy green. (You know the green.) It's everywhere
green. The nearer to the Midwest, the more it
begins to creep up like a wild vine.*

*As we walked out I had to have a coffee-to-go.
Upon taking it from the waitress at the register
I gazed at the illustration of the Majestic on the
cardboard cup. It was a line drawing of the
"original" Majestic. (My wishful speculation.) I
spent a moment in silence just looking at it, and
the waitress said to me, ". . . the Majestic, that's
us." I looked up at her and smiled, with the same
feeling of pride. And that was majestic.*

*As we walked out, another early visual
experience confronted me: a bright yellow
Colonial Bread truck. I always loved these trucks
as a kid. They haven't changed—except for the
truck models themselves. It's so refreshing these
days to see an old logo still being used. Most
companies have to have their hoked-up graphics
right up to date. The sight of the truck and the
reacquaintance with the "May-Jay" made me
very happy.*

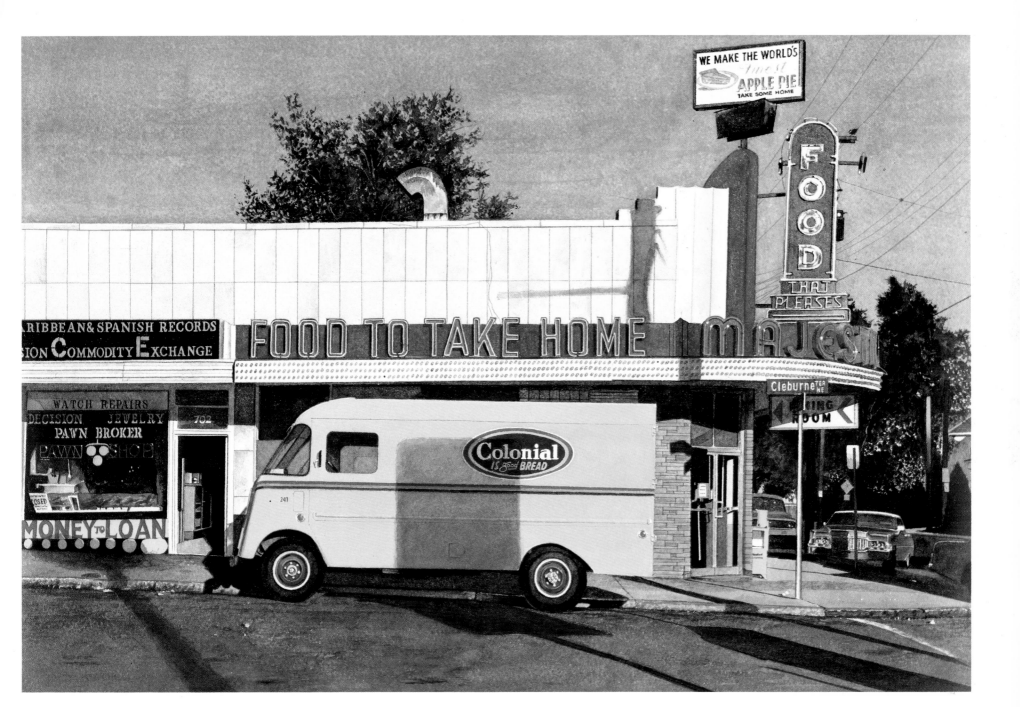

Our turn to be seated in the dining car. More windows. We ordered our meal by writing on little mint-green pieces of paper (or were they beige?); the railroad also provided a little yellow pencil. And I watched my father write with his great European cursive script (on the white tablecloth with the thick silverware). And as he pressed down on the soft tablecloth, I'd take a break from the window and watch him write our order. People would come back and forth, and I especially liked all the soldiers. I'd look at their campaign ribbons, a swoosh of colors, like looking out the windows of the train. All those many colors neatly placed side-by-side above the heart.

I was a picky eater as a child, or so I've been told; but I ate myself silly in the dining car. I was a *diner* in a moving restaurant. Better than any amusement park. Clickety, clickety, clickety, clickety, clickety . . .

Then, more scenic dramas entering Chicago. Miles and miles of bleak industrial buildings. The train began to reduce speed, and I hoped it was being slowed down for me to be able to see more. (Slower speed, more pictures.) There were rows and rows of auto junkyards. Oh, I wanted the train to stop so I could get out. Rows and rows of slums followed. And rows and rows of freight trains: all those names, and logos, and lettering, and all the funny codes; what a kick. We were in Chicago, and the train pulled lazily into the station. Off the train; good-byes to the conductor, hellos to the Red Cap. Then we would manage to get into

my favorite taxicab (even today), the New York- and Chicago-based Parmalee System Checker Cab. What a car, that Checker. Those upswept front fenders and the short "fast-back" knocked my eyeballs for a loop. We'd rush over to another station to take an interurban train, the South Shore (which ran along the south shore of Lake Michigan), to South Bend, Indiana (on the south bend of the St. Joseph River).

My third memorable diner experience happened with my uncle in South Bend. One night, after family dinner served on up-to-date Fiesta-ware, I asked my uncle to drive me around. I wanted to see the sights of a small city; he wanted to take me to a softball game in the park down the street. I was tired of that—Popsicles and softball and swings and ducks—I wanted to see the sights, but more than just the pretty homes. I liked the stillness, the change from light to dark to darker. I enjoyed perceiving that transition while moving in a car and looking out the window. Like so many small towns at the time, South Bend had numerous bricked streets; my aunt and uncle lived on one: Park Avenue. I liked the sound of the tires; it was soothing, that low rumble. And when my uncle would brake I'd listen intently to the fade of the sound.

On the main street, East Michigan Street, there was what seemed to me then a funny-looking house on a corner, funny-looking because it didn't face either street; it faced the corner. There were a couple of huge trees that masked the green house with orange trim. In between the trees

was the front door, and above the door was a Coca-Cola sign, the one with the pretty lady getting ready to take a swig on a bottle of Coke. She's looking at you with a tiny flirt in her eye. ("Come on over, kid, and have a swig of Coke with me.") Gosh, I liked that place immediately; I knew it was different and that it had some special meaning for me. I asked my uncle if he knew who lived there, that funny-looking place with the Coca-Cola sign, and the door in the middle, and the rows of windows to either side of the door. He took no interest in my question and changed the subject; he wanted to catch the last innings of the ball game.

About thirty years later I asked my uncle if he'd ever eaten in what I later learned was the Al-Ruth Diner (Al and Ruth Ankenbluck originally opened the diner in 1929). He said he'd never heard of it. I was astonished since it was on the main street of South Bend, and he'd lived there since the early twenties. When I told him I'd just been to the diner, he finally condescended to mention that he slightly remembered the place.

My uncle was a great childhood pal during those short but intense visits, but he couldn't bring himself to like diners. Oddly enough, Lee Miller, owner of the diner since 1938, knew who my uncle was and graciously understood why I was never brought there as a child. I visited Lee on a fresh, white New Year's Day. He was hand-slicing paper-thin home fries. No more trees. No more Coke sign. The diner was as white as the snow. It had a hint of red trim—Lee's living Christmas card.

Silver light was pouring into the dim interior. Lee was a camera-bug and showed me envelopes full of his photographs. He had scenic photos plastered on the far wall by the cash register and candy counter. We talked about photography, and diners. I took pictures of him by the grill, and pictures of the interior (a very unusual diner, from Mansfield, Ohio). Pictures of the exterior, especially the old, worn Dentyne sign on the front door with a smiling lady who reminded me of the Coke sign. A snowy-white diner afternoon. I walked inside and had my usual. Took more pictures, paid up, and said good-bye sadly. Lee knew I loved his diner thirty years later. As I walked out, he handed me an envelope, and I thought to myself that it was a nice present, maybe a photograph of Indiana landscape. I opened it cautiously. It was a large picture of Lee Miller as owner of the Al-Ruth Diner, posed ever so proudly behind his counter with his hands folded, and grinning at his wife and friends sitting at the counter facing him. The picture was taken in 1938, the year Lee Miller bought and opened his diner. The year I was born—in South Bend, Indiana, on Christmas Eve, 1938.

Whenever I see cars parked
beside diners, they remind me of
piglets getting a sandwich from their mom.
It has to do with nurturing, scale, and gesture.
"Oink's" is a fantasy of chain type Bar-B-Que
oriented diners — their slogan: "Come In and Pig-Out"

DINER—CAMP HILL, PA.
Oil on canvas, 60 × 72", 1973
Mr. and Mrs. James S. Morgan Collection,
Shawnee Mission, Kansas

This was my first diner painting in natural color,
following the grisaille paintings. I needed to paint
from my own photographs, and I needed color.
It was a big leap. By this time I was thoroughly
committed to diners, and this is the pivotal paint-
ing.

Kindred spirit Claudia Stein told me one
eventful day to cross the Susquehanna River
from her hometown of Harrisburg, Pennsylvania,
and to swing around the curve after the bridge
and go up the hill. Sure enough, there were two
great diners, and neither had its name glaring
at you. They both were unusual sights.

This is a stereotyped diner, made by the Jerry
O'Mahoney Co. around 1940. I say stereotyped
because for me it is a quintessential diner. It is
truly a building as sign. A place to eat; we all
know that. There are still many people who don't
connect the architectural style of a diner with
function. It is because diners are nonarchitecture.
They weren't designed by architects. But we all
know a diner when we see one. Not so! Therefore,
the ugly yellow plastic sign: DINER.

CHARLIE'S
Oil on canvas, 18 × 30″, 1975
Richard Brown Baker Collection, New York

There's a reason for everything we do, and yet those reasons cannot always be explained. Charlie's was an enigma. Coleridge once said that every work of art must have about it something not understood to obtain its full effect. I can go along with that.

I like Charlie's paint job (I think it might be 1968-House Beautiful-"Goldenrod Yellow"; I'm not sure) and Charlie's attempt to repersonalize the diner with his hand-painted name-sign, which is close to being a logotype. Perhaps Charlie was trying to recapture the Gothic Style signage created by the Worcester Lunch Car people; take a look at the Day and Night Diner.

Charlie's is a small painting, but there's a strange bigness to it. The mood was small, and at the time I was feeling the dominance of the space around me and the diner. The shadow grew and moved in on Charlie's as the diner sat comfortably at rest preparing for dusk.

OMAR DINER, *Watercolor, 9 × 14″, 1977*
Courtesy Morgan Gallery,
Shawnee Mission, Kansas

*Have you ever been traveling on the road and
noticed that people leave their unusable cars in
their back or front yards? The lawns are usually
neatly mowed around them, and there's this rim
of taller grass that frames the car. I'm enamored
of this form of relic display—which I find
everywhere: rural, semirural, and sometimes
suburban areas.*

*The car is not abandoned; it is a reminder of
the past. There is sentimental attachment, and
it becomes, with age, some form of icon.*

*This is what happened to the Omar. The owner
decided to keep the old diner; it was part of
him, so why throw part of yourself away? Just
like those cars that are extensions of self. The old
Omar wasn't even used for new customers, the
owner wanted to keep it the way it was. Sad;
it was a storeroom: throw-all type. Downstairs
were the original eighteen stools. Some of the
original glass windows were intact. They were
the style that had etched-glass curtains. Golly,
I couldn't stand it. I wanted those windows. (I
managed to retrieve some etched windows from
a diner in Milford, Massachusetts, but they got
lost. Another story I don't want to talk about. It
hurts too much.)*

*In the mid-50s the new Omar came to join
its counterpart and cozily nestle with it. They
caress each other cheek to cheek and they will
never separate. Protection is guaranteed by the
house next door.*

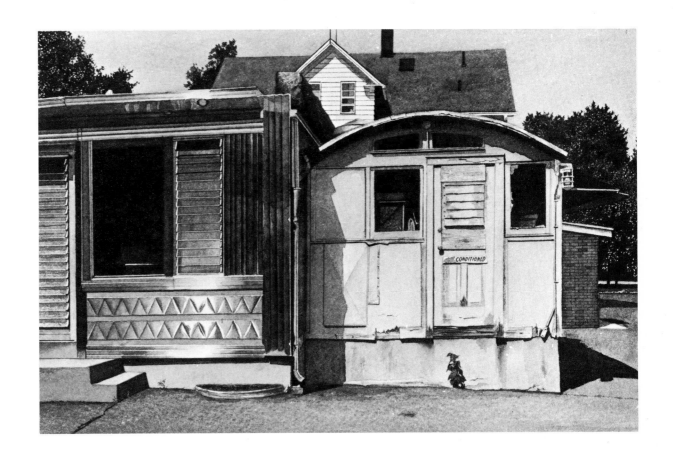

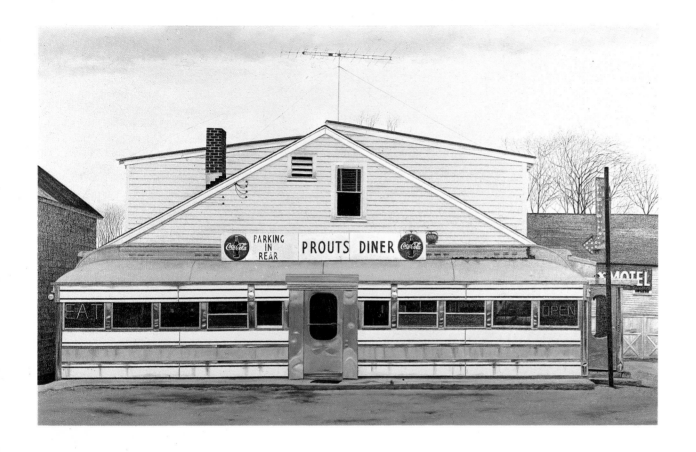

PROUT'S DINER
Oil on canvas, 30 × 48″, 1974
Mr. and Mrs. Robert Mann, Jr., Collection,
Mission Hills, Kansas

"Prout's" happened in 1972. It's in Sussex, New Jersey, near Port Jervis, New York. Sometimes places don't make any difference, just like the builder of a diner doesn't make any difference. It's what I get from the diner, and the experience, and the painting. Prout's is the kind of diner you'd not expect to be around for another five years. I returned to it five years later: still there, same color, same everything—like it was sealed in a vault. It had a few more gray hairs and needed some cosmetic work; that's all.

There's a thrill looking inside a closed diner, the older the better. Looking down the counter, you see the reflection of light hitting the stainless steel cabinets. The grill has a special crisp flatness. The napkin container and salt and pepper, they take on something that they're not. The reflection of the sugar in its container—like watching frozen rhythm. Hard to explain. I must paint these images. The light bouncing off the floor, onto the stools, up the windows. Outside. Inside. Paintings inside paintings. Stories within stories.

CURLEY'S DINER
Watercolor, 11 1/2 × 17″, 1977. Private collection

I frequently passed Curley's Diner in Stamford, Connecticut, taking notice but mostly ignoring it completely. Located downtown (which has changed dramatically), Curley's kept its cool and sat quietly across the street from a park with a statue of Columbus.

I went in and started talking with Mike, a friendly counterman, who was telling me a little about the diner but more about its ex-owner, Curley: "He retired about five years ago, but he comes in every once in a while. . . ." Suddenly, Mike recognizes a late-model Chrysler pulling

up across the street: it's Curley. I start getting excited and feel it's going to be a good day. Mike makes the introduction, and we start talking diners.

Curley (His real name is Herluf Svenningson.) tells me the diner's location has been a landmark for over sixty years. "There's always been a diner here . . . this one's a Mountainview, a '49. There was a Tierney here before; or maybe it was an O'Mahoney. I can't remember. . . ." Curley continues with his great gravel voice: ". . . there were about a dozen diners here. Even a horse-drawn wagon years ago. [I'm having a diner high.] Across the street was a five-stooler— Deddy's Lunch. . . ."

I ask Curley about pictures of the diner in the old days. He tells me he had had many, but they were destroyed in the flood of '55. Too bad. Curley invites me to his nearby house to rummage around in the basement, and he digs up some fairly recent pics, a lot of articles about him and his diner, and many small space ads. We turn to go upstairs from the basement, and there, resting gently on a bookcase, is an early picture, a group shot of three countermen from the old diner. I gaze and drool.

We are driving back to the diner, and Curley shouts hello to a man walking down the street, a fellow diner compatriot. He then turned to me and said, "You notice his feet? He's got diner feet." I fell into shock. I knew Curley wasn't putting me on. I got the full story of how diner types get diner feet. Flapfeet. Diner shuffle. It comes on after a period of time behind the counter because of limited foot room, especially in the older diners. You had to take short steps to maneuver around behind a tiny counter in the days when there was a grill man, a sandwich man, and an order-taker-server. Everyone had his station, and no one overlapped another during heavy biz time.

I told Curley he had made my day.

Diner feet. I was dinered-out.

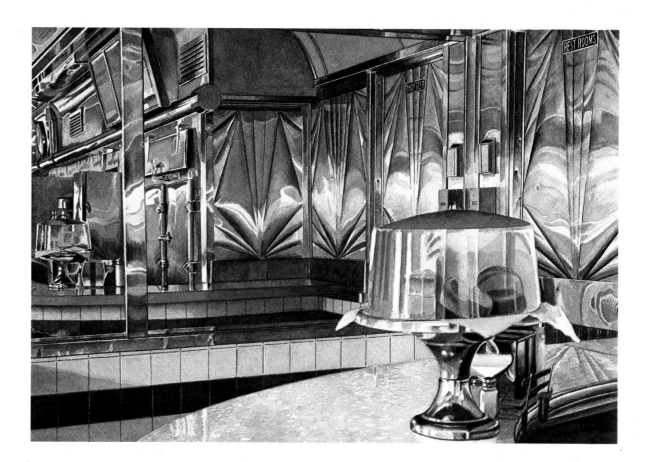

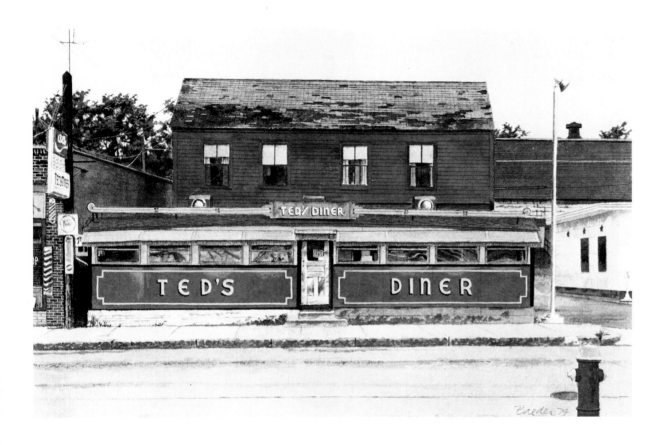

TED'S DINER, *Watercolor, 8 × 12 1/2", 1974*
Mr. and Mrs. Bernard Pashelinsky Collection,
Maplewood, New Jersey

I saw "Ted's" out of the corner of my eye one day
in Milford, Massachusetts. I drove on and don't
know why because this never happens. Milford
had a couple of sweet diners that went tumbling
down. I knew Ted's would be around for a while.
Ted's is one of those suburban diners that reeks
a sense of history and will fight tooth and nail to
be saved. It has magnitude, and freedom. Long
live Ted's.

THE "LITTLE NELL" DINER
Watercolor, 10 1/2 × 17", 1977
Courtesy Morgan Gallery,
Shawnee Mission, Kansas

I don't know exactly where mid-America is; for
me the middle of Missouri would be close.
 The "Little Nell" Diner is in the sweet little
capital town of Jefferson City. Nell Benson was
about four feet tall, or short, and opened the
diner in 1947. Wanda, just Wanda, has been
running this little homemade gem for the past
several years.
 Walk into Little Nell's and you're attacked by
Landlord Green, crawling over the walls and
counters and stools—even the kitchen. There are
about five pinball machines that break the green
silence. They date from various vintages. Take
your pick while you're waiting for Wanda's
specialty: brain sandwiches. Wanda says she
always runs out; everyone orders brain
sandwiches.
 Thanks, Paul Dietrich, for introducing me to
Little Nell's.

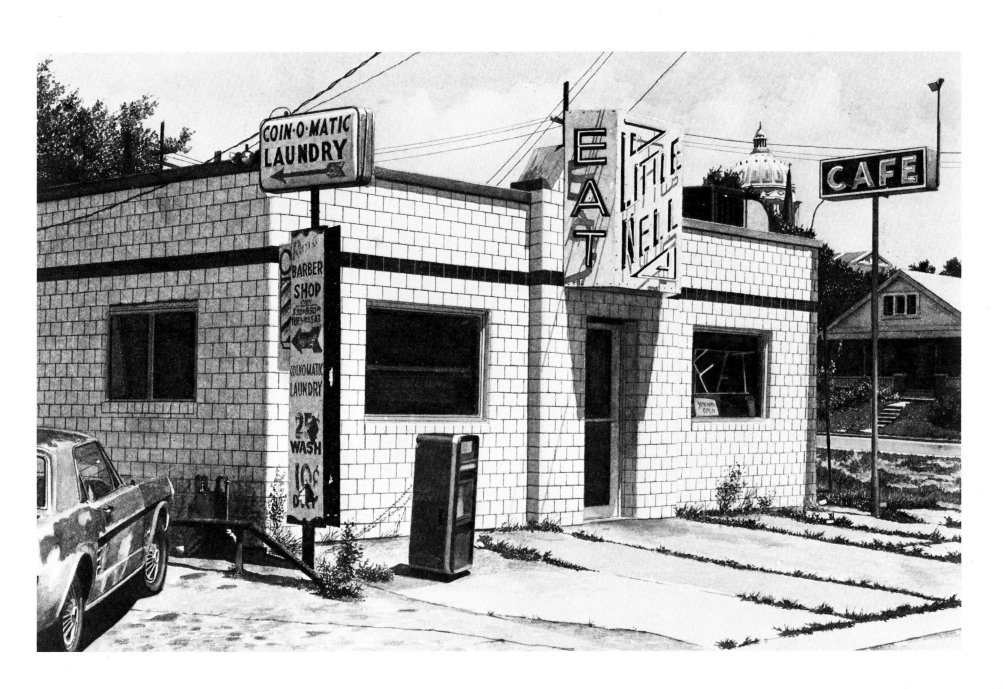

MATCHBOOK—BOULEVARD DINER
Watercolor, 3 1/2 × 6 1/2″, 1977
Collection of the artist

In the days when promotion wasn't too expensive, diners would pass out free postcards and matchbooks. Upon investigating the artwork, one might say diner matchbooks are tiny primitive paintings. Some diners still have postcards, but one has to buy them. Once in a while there's an interesting menu cover like that of Davies' Chuck Wagon Diner in Denver, Colorado, which is wood-grain imprinted and framed by rope-enclosed cattle brands. Inside the frame are line drawings of their sign (an aproned cowboy with one hand pointing to the lettering "Davies' Chuck Wagon" and the other gesturing toward the diner), the diner shown amidst rolling Colorado clouds (and a greeting: "Howdy Folks"), and a well-stocked chuck wagon with a cowboy out front kneeling with a skillet over a fire. Two horses graze in the distance.

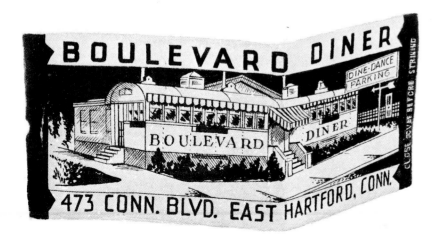

THE LITTLE HOUSE CAFE
Watercolor, 13 3/4 × 19″, 1976
Barbara and Joe Tabor Collection, New York

"The Little House" is in Albuquerque, New Mexico. This beauty has been there since 1947 and has remained pristine ever since. I believe the oversize hamburger graphic is a later addition (probably put there due to fast-food competition). It was the last of seven in the Albuquerque area. Most of these Valentine-manufactured diners came in pristine white; if they are seen in other colors, that's the result of their owners' working them over.

I have seen these diners used as real-estate offices, barber shops, antique shops, used car offices, and bakeries. I found one abandoned between Santa Fe and Taos named "Camel," and the name intrigued me. Later I learned that nearby there was a piece of land humped like a camel. Naming of diners can run the gamut.

Incidentally, the name "Little House Cafe" brings to mind an idea, or rather a conviction: diners "specialized" in home cooking, but everyone familiar with diners knows that. I wish not to mention names, but many fast-food emporiums have this in mind in pushing their No. 1 Specials: "Home of the Whopper" (Home/Biggest); "Home of the Big Boy" (Home/Biggest). Big this, big that.

One out of every three food dollars is spent eating out today. That's why all of these new diners, and restaurants, and fast-food parlors are all bricked and beamed and carriage-wheeled and lamped: the "Americana" getting-back-to-home look.

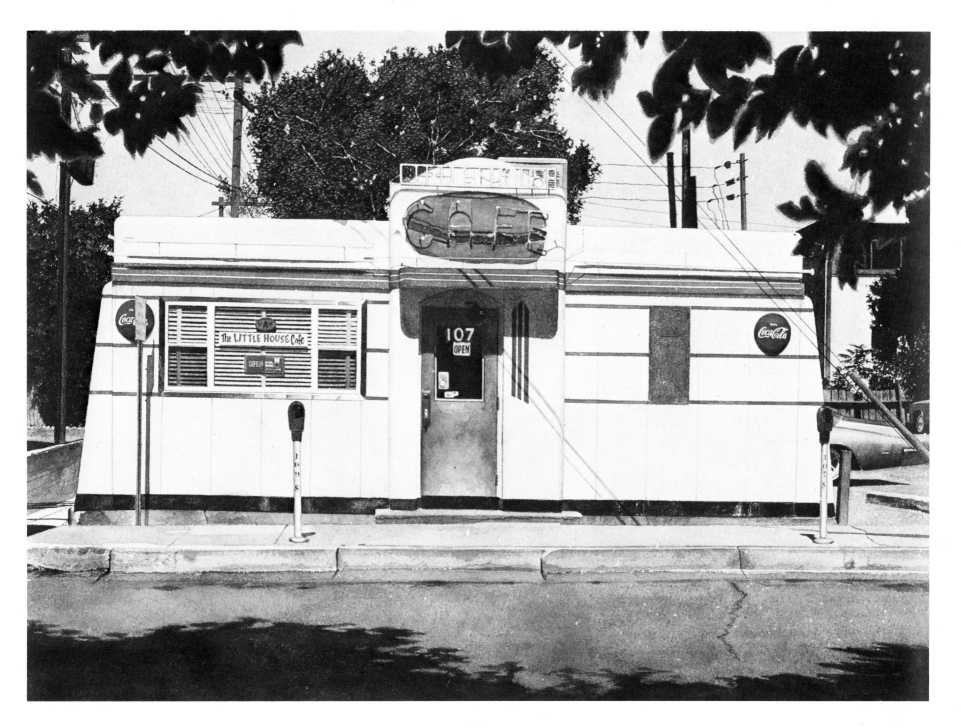

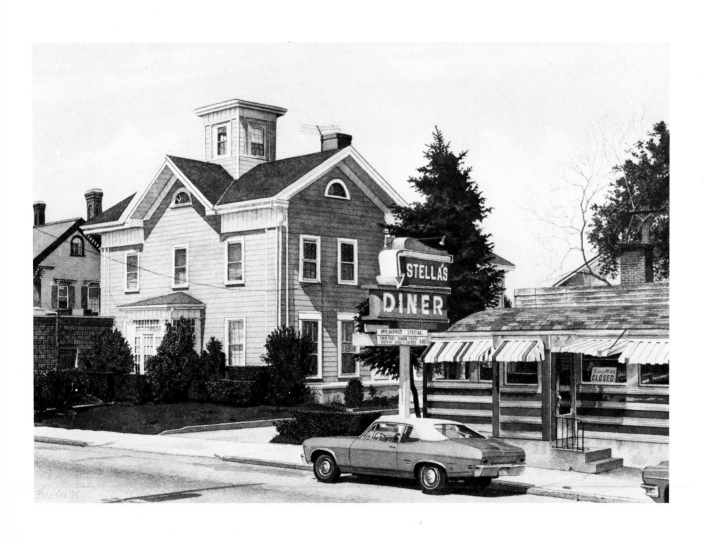

STELLA'S
Watercolor, 11 3/4 × 17 1/2", 1975
Jocelyn Stevens Collection,
London

I like suburban diners. Many are sweet. Most are friendly. Some of them remind me of little old ladies bending over in their front yards picking flowers, or weeds, or replanting. Their backs are always facing you, and shady trees surround them.

Stella's, in the pleasant town of Woburn, Massachusetts, wasn't enough for me just by itself. It was a tame and immaculate diner. Something was missing. I walked across the street, found myself a better vantage point on a slight hill, and it all clicked. I linked Stella's with that wonderful house; it needed its environment, a friend, that house. The contradiction of form creates a tension needed to give the diner its essence.

The car became a visual staple. For me, there's always a definite reason for putting in or taking out a car. With some diners cars are an intrusion, with others they are an integral part of the diner and its personality.

24

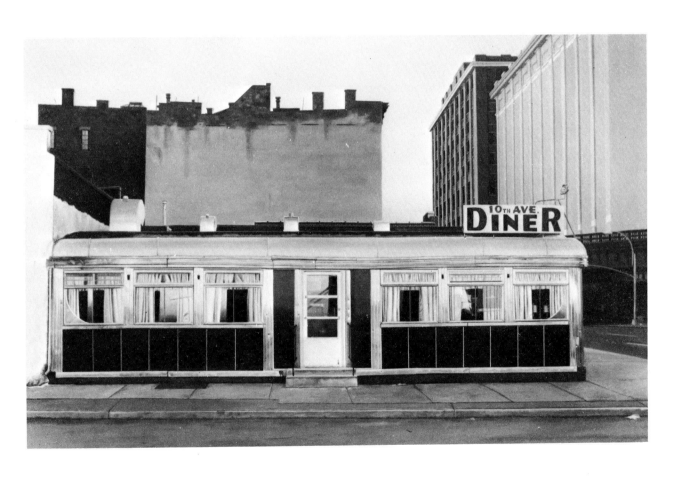

10th AVE. DINER
Oil on canvas, 30 × 48″, 1973
A. Haigh Cundey Collection,
Essex Fells, New Jersey

*When I painted the 10th Avenue Diner I
was in a void—personally. I think the diner
was in a void, too. I was never able to
believe what I saw sitting there on the
corner of 18th Street and 10th Avenue in
Manhattan. It was too good for its
environment, a nice diner that needs some
nice friends; it got in with the wrong crowd.
It gave off a coolness, both in color and
attitude.*

The Mansard roof plague is upon us. In Arizona I came across a total Mansard mobile home, which was the inspiration for the Mansard diner. Mansardized diners in all grotesque styles are all over, and soon a full Mansard will be with us.

MAPLE DINER, *Oil on canvas, 42 × 66″, 1973. C. Dick Belger Collection, Kansas City, Missouri*

Fall is my favorite time of the year. The symphony of color, light, and mood provides a different kind of energy for my travels and searching.

The first two weeks in October are the best. The sun starts to take its rest and settle down. I have yet to capture this extraordinary light. Ironically the "Maple" is a fall image, with a fall look, and fall colors. It was not intended to look like a department store window; it just happened. Occasionally I go out to rephotograph diners under different light conditions, and most times I am surprised to find the diner:
1. still intact and nothing changed;
2. remodeled and face-lifted (losing all personality and character); 3. replaced by a new diner (as happened with the Maple); 4. gone forever.

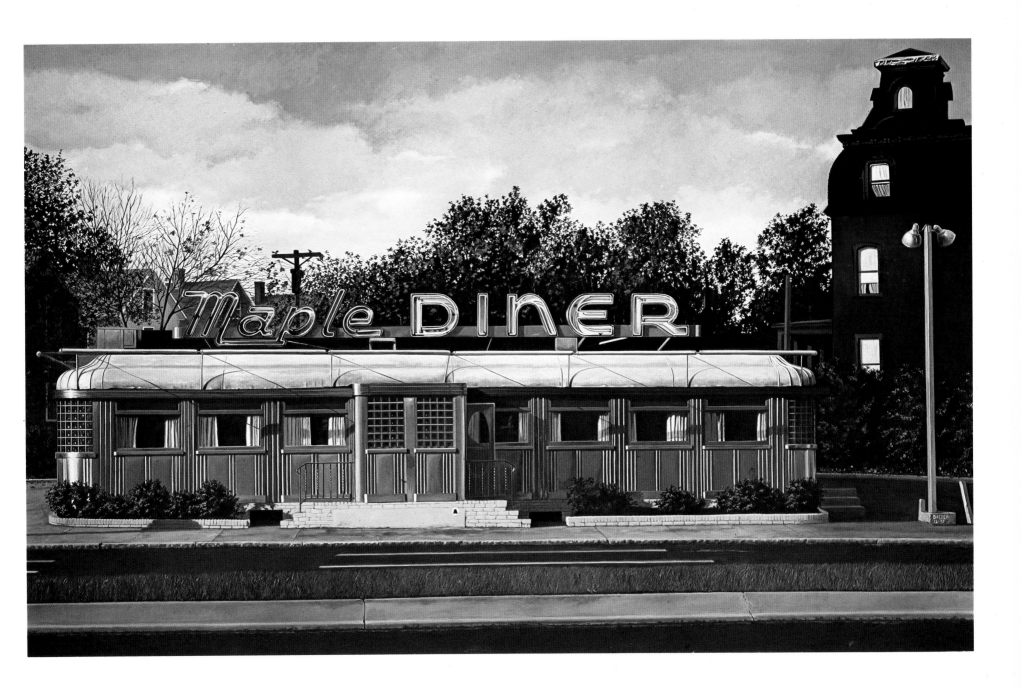

o every kid, Saturday is the greatest day in the entire world. Saturdays have to last as long as a week. Saturdays have to exhaust imaginations, stretching them to every length. Saturday; golly, that was the only way we got through school, looking forward to that special day. Saturday was "Majestic" day. (Yeah . . . the Majestic Diner again. Several years later, and a different location, but it was the majestic Majestic, the same juicydrippy hamburgers, the same chocolaty pie. The taste buds would improve within six or seven years.)

I remember a lot of Saturdays. At the Hilan Theater, it was 9¢ for "under twelves" then. The Plaza was 12¢ for "under twelves," but it had double features and serials and better popcorn. It was larger, too. That made a difference. My friend Ron Balser and I would hike down on our bikes. It was a good distance—several miles. Our Schwinns were in good shape. We took our time; lots of hills, both up and down. Race, slow down, race.

We got to the Majestic and whoofed down our burgers, and always made it in the nick of time for the first show. Coming attractions were as long as the feature. Second show. Serial. Glaring sun. There was a bowling alley a few doors down from the Plaza Theater, and we'd bowl for a couple of hours. The Majestic was on the corner of the bowling alley,

and in we went for some pie. I had to have more of the Majestic, sitting at that low counter slurping chocolaty chill. On the opposite corner, on the other side of the theater, was an all-night drugstore which had a huge newsstand where we'd do the magazine-thumbing bit: just stand there, chew gum, and readlook-lookread at magazines. The hours had gone by, and the minutes were creeping up on us; we didn't care about getting home. Dinner always waits for two kids in love with stretching a day. Saturday stretch. We'd bicycle home deciding how we could elongate the evening. More movies perhaps . . . but the Majestic would have to wait until next Saturday.

Today, all of us, no matter which age group, have a love affair with our bicycles. It's competitive, and there's a great deal of status in bike-dom, part of the label-conscious society. When we were kids, a bike was a bike; it got you where you wanted to go. It was an extension of your-self, not a two-wheeled piece of jewelry.

My bike took me everywhere, or I took it everywhere. No "speeds" then, just your own legpower and willpower. I am reminded of all this because I have traveled great distances in my car: searching, looking, seeing, finding. Taking pictures and more pictures. It was the same when I was younger and on my bicycle—maybe to a lesser degree. I'd leave home in the early morning armed with my Baby Brownie and I would ride and ride, going into all kinds of neighborhoods, taking pictures of old

cars parked on the street. I'd find one, and another one would pop up. And another one. Now, these were really old cars, dating from the early twenties on into the late thirties. There were hordes of old cars around, one after another. I still have the pictures in the same old cigar box I used in 1950. Something was happening then, but I didn't know what it was. There was a sense of travel and searching and adventure. It was highly visual, the past involving the present. Today, drugstore variety pictures are hip, and the same imagery is also hot with many artists and photographers, not to mention many "realist" painters.

(Eventually I outgrew the bicycle and ended up behind the wheel of a Robin's Egg Blue Olds 88. I drove around a lot, but searching most often for "parking places"—not the "parallel" variety. No more old cars, no more diners, just drive-ins, but an extraordinary number of drive-ins for a while, both movie and food. I was listening to *real* country music and gospel. Rhythm and Blues were just beginning to hit the radio waves [I'd dial down from the R & B station to the country station—two minutes of Webb Pierce and two minutes of Elmore James. Two cultures, one emotion]. The musical forms had a similarity of color, and I loved them both. Passionately. Which reminds me of something delicious that Baudelaire wrote: "They live to live; we, alas, we live to know . . . only those will understand me for whom music provokes ideas of painting.")

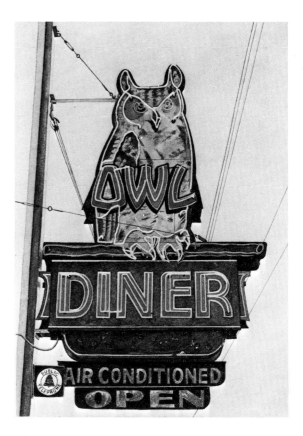

OWL DINER, *Watercolor, 12 × 8 1/2", 1977*
Courtesy Morgan Gallery, Shawnee Mission, Kansas

MAX'S GRILL, *Oil on canvas, 30 × 48″, 1974. Collection of the artist*

"Max's" happened one flat day in Harrison, New Jersey. I was traveling through Newark, and Newark isn't much fun to travel through, not much of a place for a weekend, weekday, or weak moment. Nevertheless, the muse was with me that day, although she was as tired as I was. A left turn came my way, and before my foggy eyes was a stretch of Harrison Avenue in Harrison, New Jersey. I was getting closer and the cloud had lifted. (The tourist folders don't tell you these things.)

There was Max's on the right, minding its own business among all the low-level visuals Harrison has to offer. I don't know who made Max's—maybe Tierney—and it doesn't matter; I knew it was old. Early 20s. It was a pleasure to see it in the original porcelain; the interior was mint.

I realized that it was more normal to find early well-preserved diners in outlying, cleaner neighborhoods of small towns and rural areas. Max's was exceptional.

The Newark funk had passed, and I was properly nurtured by the discovery. The light was soft and rosy, and it was a typical wintry overcast day—days I loved and needed so much at that time. I was of the mood; we were one and the same. The absence of light and shadow, stillness and solace: deeper perception. I looked around and felt aroused by the flatness. It was as if a giant finger came along and reduced space and volume. The experience became more beneficial when I was in the process of painting. I realized a different focusing. Touching with my eyes.

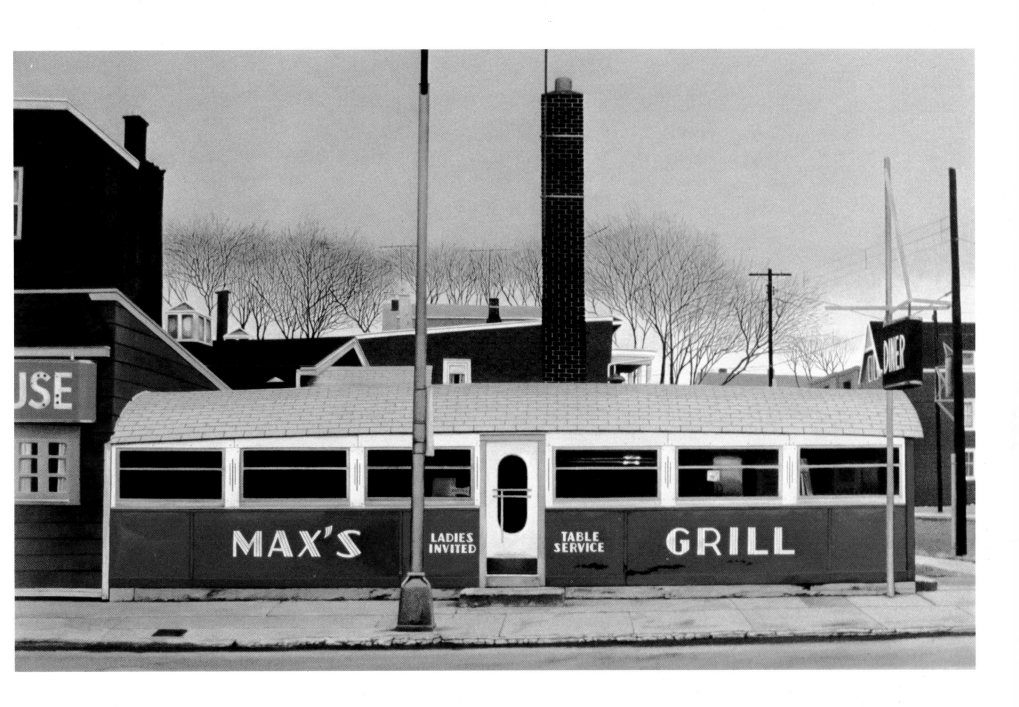

AIR LINE DINER
Watercolor, 8 × 12″, 1976
Bill Bostleman Collection, Houston, Texas

*Whizzing out to LaGuardia or Kennedy airports
in New York, one can easily miss the Air Line
Diner, which is very close to LaGuardia. I'd pass
it innumerable times and promise myself to stop
there soon, for fear of the diner's being
demolished, but knowing the best part was the
signage. I wanted to do a dusk or night painting,
but the diner didn't make it. Only the sign did.*
 *It shares the "Constellation" neon with the
Skyline Diner in Langhorne, Pennsylvania.*

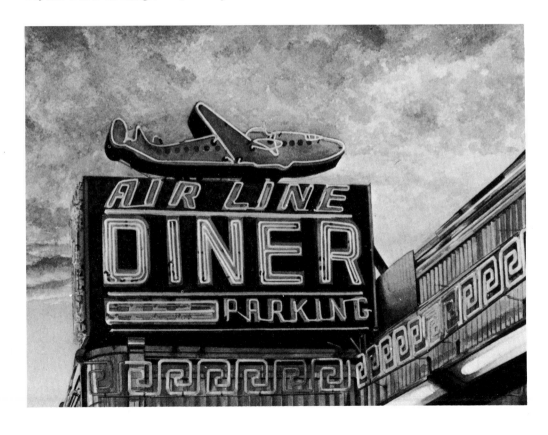

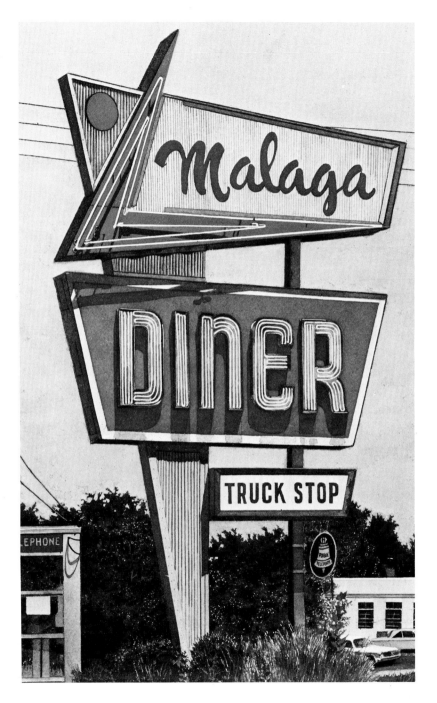

MALAGA DINER
Watercolor, 14 5/8 × 9″, 1976
Collection of the artist

I have a lot of "shape" obsessions. The
"boomerang" or "kidney" is one of them.
Boomerang signage started in the early 50s in Las
Vegas, sign capital of the universe, and when the
first boomerang sign went up it spread like kudzu
all over America, hitting motels first and then
attacking mild-mannered commercial enterprises.
To find a diner using any form of boomerang is
a pleasure for me, especially in turquoise and red.
Golleeeeeeeee!
 And to think Picasso was born in Málaga. I
wonder if they serve Spanish rice? . . .

CHAPPY'S DINER
Watercolor, 13 × 19″, 1976
Mr. and Mrs. Robert Margolin Collection,
Kansas City, Missouri

Paterson, New Jersey, is a good place for a
Sunday drive. And a good place to get lost, like
Newark. But it's better than Newark. I was
driving around after photographing a diner that
was great but didn't work; what worked was a
"Go-Go" palace around the corner—a great image
that I did a painting of. Drove around some
more and started to get itchy for a diner. Fell into
an industrial area ("No place to eat around here,"
I thought). Felt a left and did a turn across the
railroad tracks and onto a main road. That was a
good clue, and I was getting warm. I hung a left,
and Chappy's was on the left, taking a Sunday
snooze.
 I liked it from the side. There was a rhythm
that I was impressed with. Subtly it reminded me
of a collage. (Homage to Schwitters)

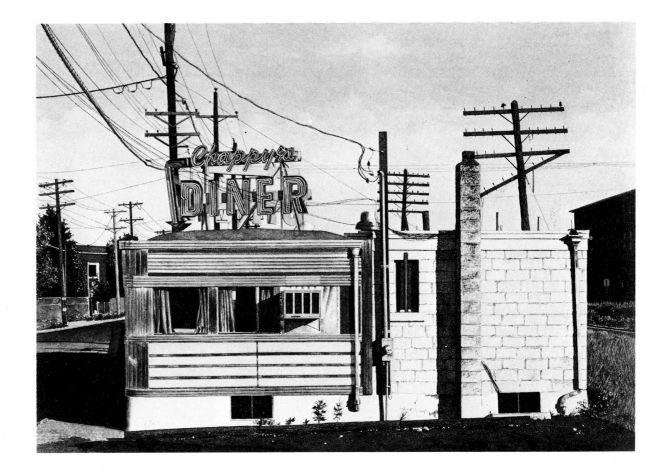

WHITE MANNA HAMBURGERS, *Oil on canvas, 30 × 48″, 1974*
Larry A. Belger Collection, Kansas City, Missouri

White Manna was a small chain established to compete with its bigger brothers White Tower and White Castle. Most of the major fast-food hamburger chains are destroying these businesses. There are just a few "Mannas" left, all located in New Jersey. This one is in Hackensack. I have no idea how many originally existed.

The idea of using the "white" theme bears importance. In the early 30s when there were no FDA and state food regulations, these diner operations were established on a chain basis. "Storefront" or "diner" food was thought to be second-rate. (The spoon had already been greased.) So, to reconfirm the notion of cleanliness and purity, the "white" theme was devised. Also, combined with "manna," this notion was intensified by the Biblical association—small pieces of bread falling from heaven—pure and white. There may have been direct and indirect responses to this idea.

Early White Towers were of castlesque architecture, and later they were switched over to the more "modern" look—keeping up with the times. White Castle capitalized with their miniature castles.

The pure white porcelain enamel which is combined with the semblance of a castle or a tower (everybody wants to get to the top) might psychologically motivate customers to devour their food at these places. There were others, like White Turret and White Star, which attempted to emulate their competition, but no one need look higher than a castle, much less a tower; however . . .

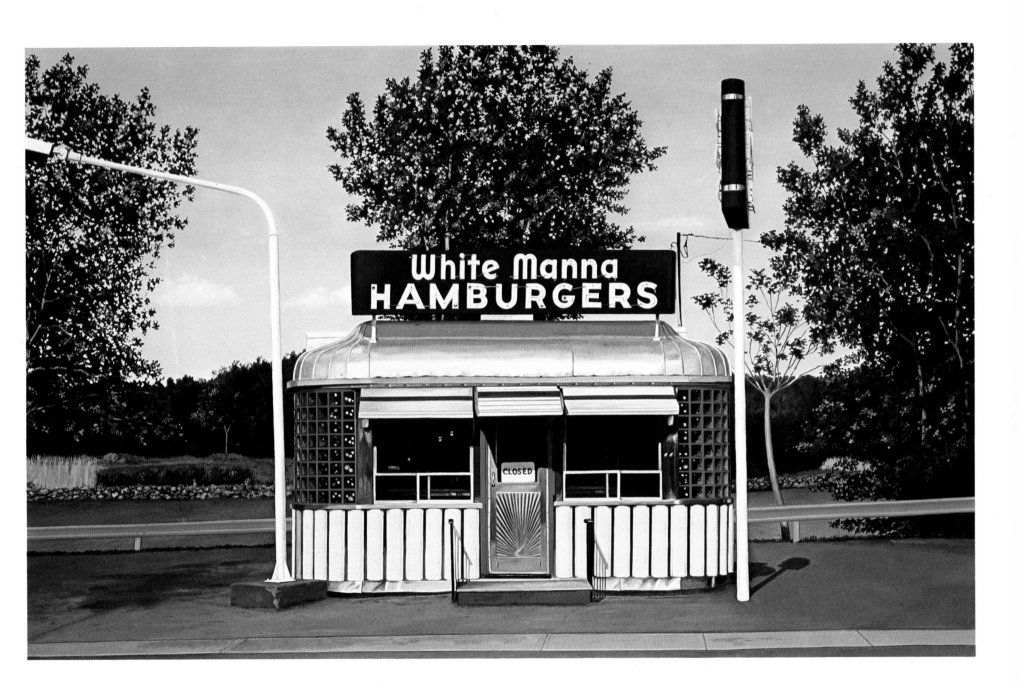

WHITE MANNA HAMBURGERS
Watercolor, 14 × 21 1/4", 1977
Private collection

*In Jersey City, New Jersey, the "White Manna"
stands regally on the busy and infamous Routes
1 and 9. As one zips by through a green light,
the Manna can go unnoticed; at red its image
changes from every direction: a different character
from each corner because of surrounding
topography. I ordered a couple of burgers and
inquired about its history. During the World's
Fair of 1939–40 it stood on the fairgrounds. After
the fair, it moved to its present location. I first
documented the Manna five years prior to the
watercolor. At that time it was appropriately
bedecked in white porcelain, with orange trim.
I asked about the recent brick acquisition and got
a blank answer. So, I answered for them:
"I guess you just had to keep up with the
times. . . ." They nodded and smiled, internally
thanking me for helping them to think.*

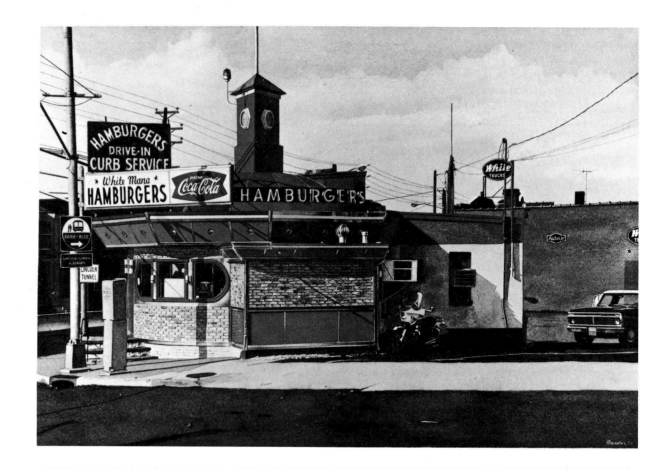

VIV'S, *Pencil, 11 × 19″, 1976*
Courtesy O.K. Harris Gallery, New York

*Diners have looks. Viv's is solid. It's an
older Worcester Dining Car that knows
what it's about. It has a mellowness and an
ease. It asks nothing from you, and I love
this quality. Viv's has a sense of
"thereness," which might have something
to do with a diner that sits squarely in a
parking area, and there's a large amount
of space that occupies it; the diner doesn't
occupy the space.*

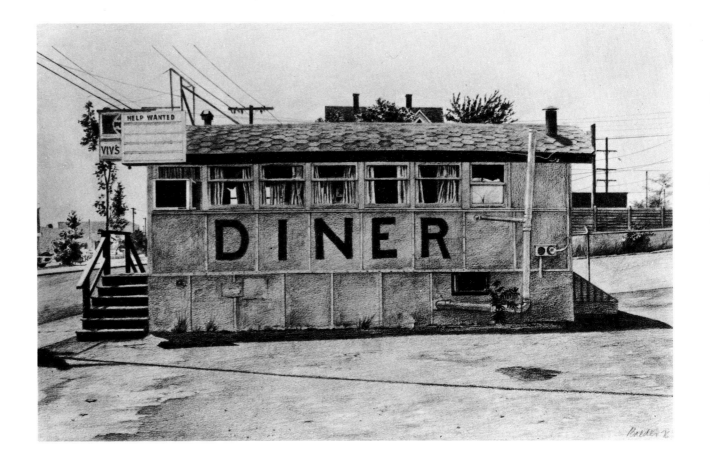

YANKEE CLIPPER, *Oil on canvas, 60 × 72″, 1974*
Collection Indianapolis Museum of Art, Gift of the Contemporary Art Society, Indianapolis, Indiana

The Yankee Clipper Diner resides in Providence, Rhode Island. I discovered it one night while lost and was again rewarded with an exceptional diner. The Clipper was closing, but its owner poured some coffee as he was cleaning up. We started chatting, and I told him how much I loved his streamlined diner. He matter-of-factly indicated that he'd been there only three years and had no inkling of the diner's history; he was in the food-service business, and nothing else. Unaware that it was a rare diner, he did not appreciate its significant design properties.

The majesty of the clipper ships was always inspirational, but probably the most famous use of the "clipper" theme was in the fleet of elegant flying boats that traveled in the late 30s to all parts of the globe. High romance. In fact, on May 29, 1939, the original Yankee Clipper took off from Port Washington, New York, for Europe and established the first regular passenger service across the Atlantic. If the diner were located in Port Washington, at least its name would have had some relevance.

For years the ship theme has been a popular motif for seafood establishments. (On a more sophisticated level, the porthole-deck-railing-rivet-infested designs carried over to other architectural areas: the Coca-Cola Bottling Company of Los Angeles is the most famous and prime example.) One of America's more popular hotels and tourist attractions is the S.S. Grand View Hotel, located on a hillside in the Allegheny Mountains eighty miles east of Pittsburgh. It is shaped like an ocean liner, with decks and railings, two smoke stacks, and even a mast. You can see three states and seven counties from its deck.

I have wanted to paint the South Clover Diner, which is in New Jersey south of Philadelphia on Route 30. It is closed and decaying, but it had a terrific false-front ship design, complete with false porthole windows above the real rectangular ones and false deck railing with two-dimensional life preservers. And renamed: S.S. Atlantis on the stern. Of course it was painted "nautical" blue up to the bottom of the windows, and white above. Huge red neon signage. I wonder what their "specialty" was.

Among my fantasy diners, I can see one now that would be perfect in the Catskills, or better yet, in Miami Beach: a huge stucco salmon with bagel-shaped and -colored windows. You can fill in the name.

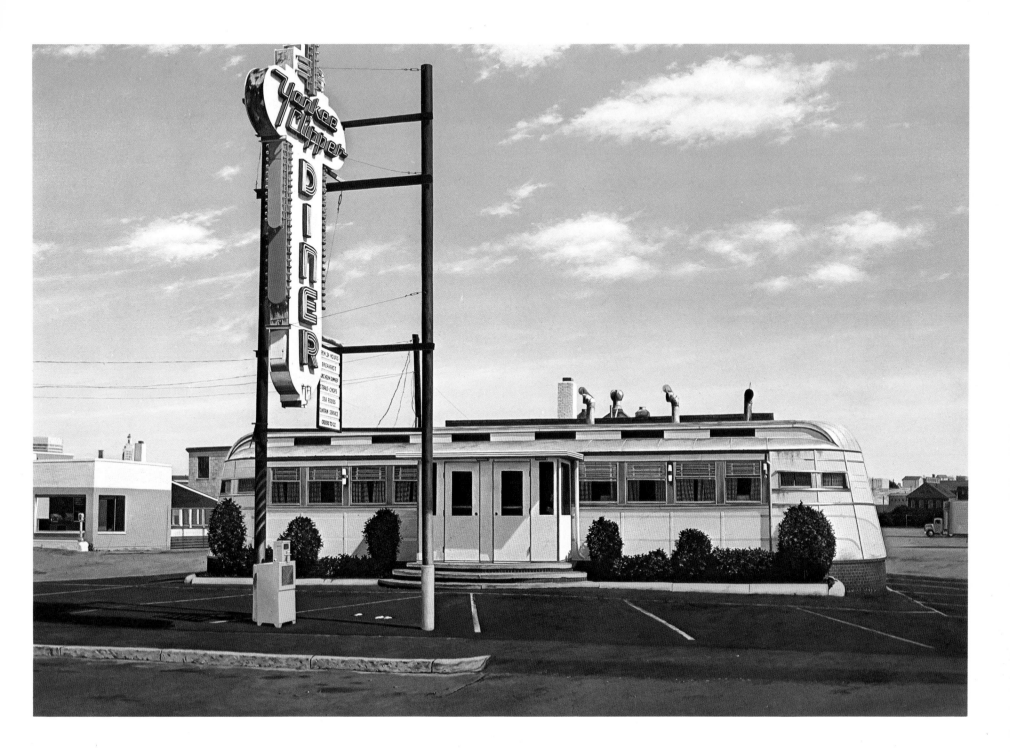

SAM'S DINER
Watercolor, 10 × 11″, 1977
Sam Perkins Collection, Olathe, Kansas

*"Yes, we have grits." Sam is proud of his menu,
and his diner. Diner as menu. I like Sam. He has
merchandising flair without being obnoxious. He
knows how to grasp those fleeing motorists on
Routes 1 and 9 in Jersey City, New Jersey. Diner
business is competitive on that route, and you've
got to get your customer and please him.*

*Grits in New Jersey. Hard to believe, but maybe
Sam has a lot of Southern truckers barreling into
his parking lot. Maybe that's Sam's edge on his
competition. Sam tried to go modern,
mansardizing in plastic-red. I only wanted a hint
of the new roof in the painting. Those
neomansard roofs repel me, and when they're
found atop early diners it's sacrilegious. At least
Sam had some respect for saving the glass brick.*

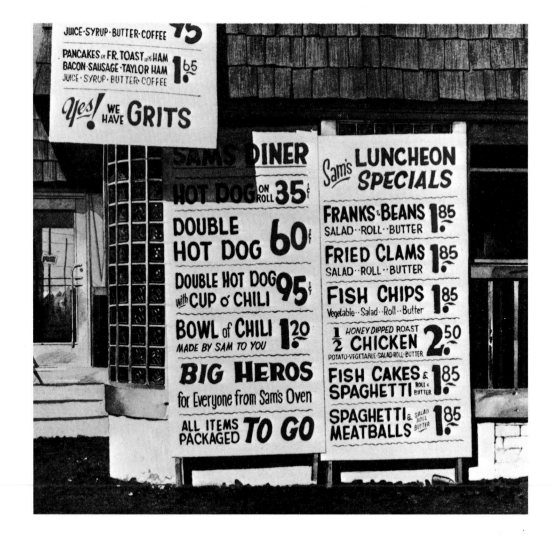

love the way all alphabets look: letterforms, signs, anything involving type and typography. I don't remember how they started to appeal to me. I recall my father coming home from his department store with ad proofs. I didn't like them and wanted to make changes—to "clean-up" the layout. My father had an art director who did all this, but I had a compulsion to take some paper and break up the column, doing it my way. My father always had these black 5B pencils. I liked the dark softness—the way they would glide on the newsprint. J was about six years old and loved drawing the letters on the page. Was that the start of admanship?

Well, it beat any coloring book. They're nasty things to have around for a kid: confining, rigid, and unimaginative. So, I'd draw in the socks, and a shirt, and slacks, and a hat or two. Letter in the headline, indicate the copy, and then the best part: lettering the logo. My father had a big fat Ultra Bodoni Caps logo. Thick and thin. Boy, that was fun. Then I'd indicate the illustrations, with my father's instructions, for the benday dot pattern. The *Atlanta Journal* used the layouts. My first free freelance job.

Like most kids I drew a lot, but didn't play around with letterforms too much. I did more ads, but got bored. It was too confining in that little space. I loved looking at magazines, picture after picture. I'd look at the lettering styles for long periods of time, gazing at the color and the rhythm, all the nuances. I always knew when a style was hand-lettered and when it was machine-made. What a kick that was.

Around the same time I would gaze at show-card lettering. Signs in store windows and on counters of stores. I became obsessed with sign painting. Especially truck lettering. I'd stare at the brushstrokes, where they went, how they started, where they ended. Pressures. The clean, crisp corners. All the tricks that went into making a letter and a word. Dots. The sweep of an S. An ampersand. A little serif. An O. A lowercase g. I liked looking at sun-soaked letters where you can see the pull of the brushstroke. Hairlines. Shadows. Striping. I loved it all. It all came from a human hand. It was art. I didn't care about "real" painting from "real" artists. This was an interest I couldn't explain to myself; it was like a quirk and I enjoyed it, kept it to myself; it was like a private language, because I knew no one else would understand.

In high school I was always the one called on to paint signs. They'd get me out of class to paint signs. It was great. I was the only one with lettering brushes, that's probably why. They worked like magic. I loved watching the letter build and watching the brush slide down the paper into a letterformwordpicture. Beautiful. Like the Chinese and Japanese calligraphers: Dip. Touch. Gently press. Sliiiiide. Hold. Press. Lift. Ahhhh. . . . Timing. Sensitivity. Care. Love. A discipline that carries over into so many other facets of life. Lettering as a maker of character.

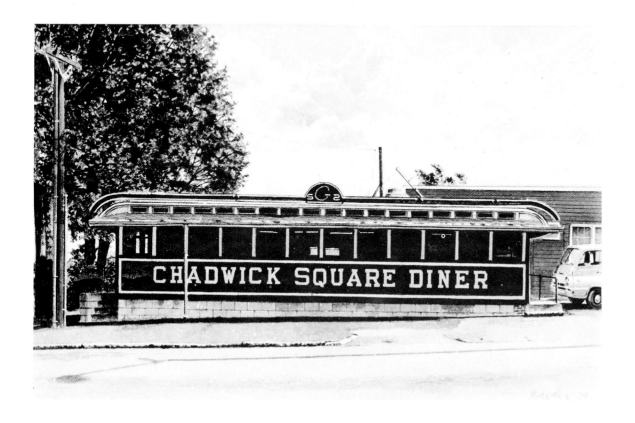

CHADWICK SQUARE,
Watercolor, 8 × 12, 1/2", 1974
Mr. and Mrs. Bernard Pashelinsky Collection,
Maplewood, New Jersey

Walk into the Chadwick Square in Worcester,
Massachusetts, and focus yourself on the mosaic
tiled floor, inlaid by craftsmen (remember them?)
who cared, and cared about tile. Tile by tile.
(The "Artisan" Diner.) Gaze up at the wooden,
polished monitor roof. Sweep down to the marble
counter. Shades of the past, you bet! Take a deep
breath, close your eyes, smell the home-baking
from the kitchen; open your eyes and you're in
diner heaven. Concours d'élégance: 100 points.

SKYLINE DINER
Watercolor, 8 3/8 × 11 5/8", 1977
Collection Springfield Art Museum, Springfield,
Missouri

Entering New Jersey on Route 1 in Langhorne,
Pennsylvania, I was confronted by a now-famous
Lockheed Constellation ("Connie" to us airplane
nuts). The long silvery fuselage, four giant,
jutting, propellered engines, and the triple tails
were painted red, white, and blue. It sits atop a
new-looking brick building, a restaurant for which
the restored airliner is the bar. The restaurant
supports the airplane. What a sight! Especially
at night, coming in from the west.
 Across the street in its shadow is the
appropriately named Skyline Diner—an
afterthought, but what a jewel. On this
Paramount diner, chrome balls adorn each corner,
like guardians of the sky, or like gods who sat
atop temples.

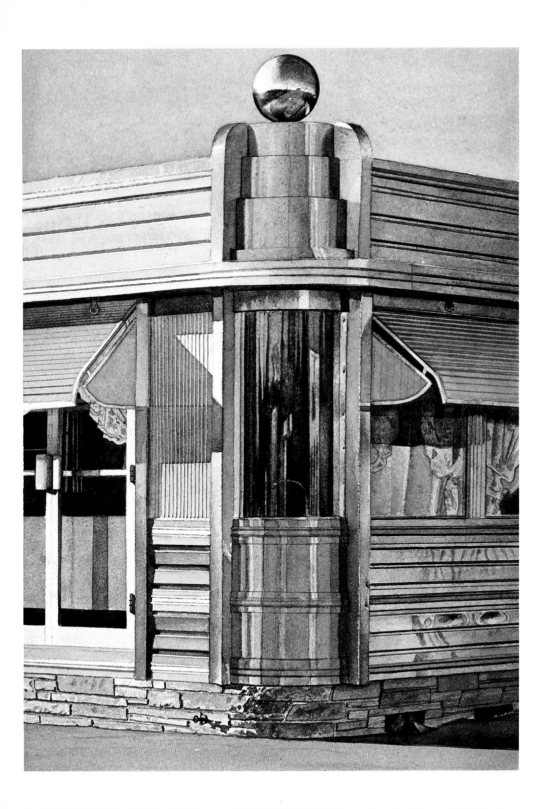

THIS IS WHAT THE SKYLINE DINER SHOULD BE,
24 HR. REVOLVING FOOD PARLOR. HOMAGE TO
NORMAN BEL GEDDES.

ELEVATOR
(à la Portman)

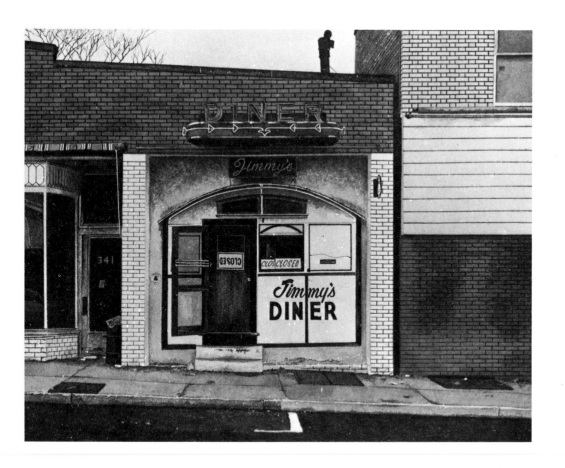

JIMMY'S DINER
Watercolor, 10 3/8 × 13 5/8", 1977
Courtesy Morgan Gallery,
Shawnee Mission, Kansas

*"Jimmy's" has another name now, like many
diners pictured in this book. Jimmy's is on the
multimiled stretch of Bergenfield Avenue.
Jimmy's may be in Orange, New Jersey. The
names of the towns change so quickly out there
it's hard to keep up with them.*

*In neighborhoods where there is high
population density and lack of horizontal space,
diners were turned sideways from the street,
where they look like storefronts with diner
features. Go inside Jimmy's—full diner, period
piece. It has windows facing the counter, but
they're beveled mirrors.*

*I liked the flatness of Jimmy's; it matched the
flatness of the day. Overcast, dusty-looking days
are important to me. There's a heightened sense
of isolation. I get closer to color, and that helps
me express light.*

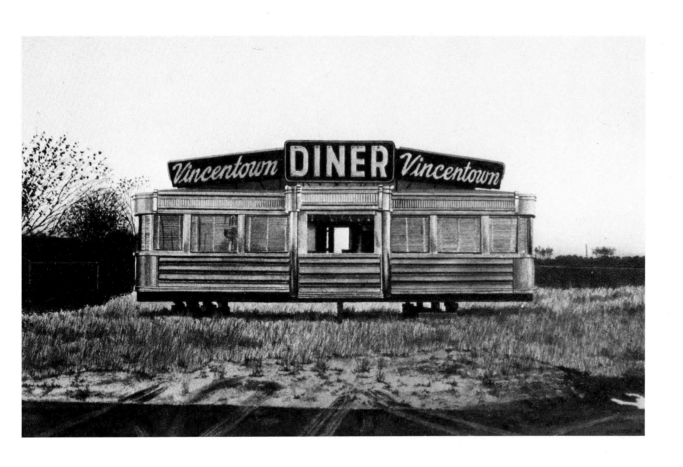

VINCENTOWN DINER
Watercolor, 8 1/2 × 13″, 1974
Stanley and Ellen Poler Collection, New York

David Slovic, an architect in Philadelphia and a very serious diner lover, showed me a picture of the "Vincentown." It was the back side. Sometimes the back side can be more attractive than the front, and his photograph of the back side was beautiful. I was on my way to visit the Vincentown.

 It sits relaxing on its logs in the backyard of its counterpart the "Vincentown-Restaurant-Diner," or "Vincentown-Diner-Restaurant," I can't remember, although it's important which gets first billing. When they grow up some diners become "Restaurant-Diners" or "Diner-Restaurants," depending on the sentiment of the owner and how he feels about his future customers. These new diners, however, are more "restauranty" in appearance.

 I approached the 50s diner as the sun fell and wondered if it wasn't time to put it to rest, and I had to think of Progress and not get teary-eyed about that reality.

 Vincentown was my first natural-color watercolor.

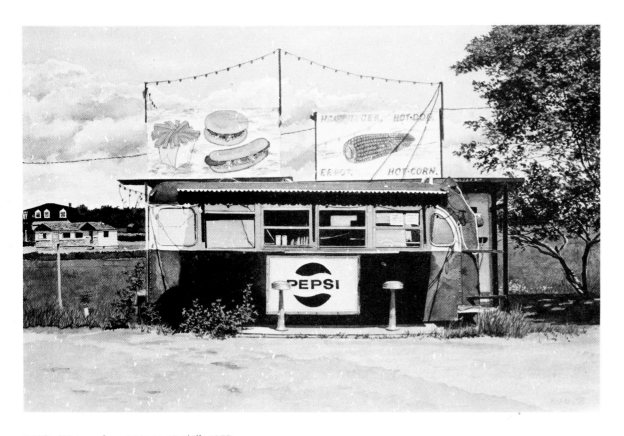

SANDWICHES
Watercolor, 6 1/2 × 9 3/4", 1975
Collection of the artist

Have you ever eaten a quick bite from one of those vending trucks? Especially the kind that has a stainless steel quilted box mounted on a truck chassis? The rear door or the side door flips up, and there are sandwiches, and cold drinks, and ice cream, and coffee. This little trailer (manufactured by the Cheerio Trailer Co. in Chicago) is the forerunner of those trucks, lunch wagon tradition down the line a few steps. A house trailer company made these units in the mid-30s; I'd give my eyetooth to have one of them for my front yard.

Up in Vermont and New Hampshire I have seen trailer-type "snack" wagons, but it was winter, and they weren't in operation. They just sit there waiting for May 30th. I've also seen many popcorn-cotton candy-hot dog trailers. I saw an old trailer diner with an outside serving window in the middle of the desert in Quartzsite, New Mexico. Now, that was a fantasy come true.

BUS, *Watercolor, 9 1/2 × 15 1/4", 1975*
Mr. and Mrs. Robert M. Wolff Collection, Shawnee Mission, Kansas

Following the trolley-car tradition, I've seen many discarded buses-turned-diners. At some you order your victuals from a window, as with the earlier horse-drawn wagons, and at some you sit on the stools provided, as in this little jewel-like bus outside Montreal, Canada.

On Route 22, in Pawling, New York, there's an old school bus pulled off the road a few hundred feet. It serves a tasty bill of fare. All the specialties are colorfully hand-lettered on signs that are plastered on the side paneling.

Inside there are several seats, converted into cozy booths. The kitchen is to the rear. Try the chili-dogs.

Close to Danbury, Connecticut, on Route 7, is Mary's Diner, another school bus-turned-diner, with four stools up front by the driver's seat and a large carryout window on the side. As Mary was preparing several footlonghotdogweenies, she told me in detail about her laborious red-white-and-blue paint job for the Bicentennial.

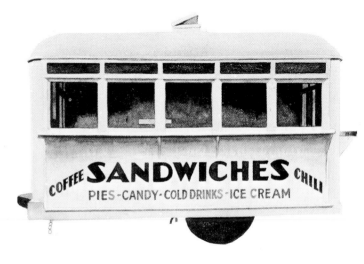

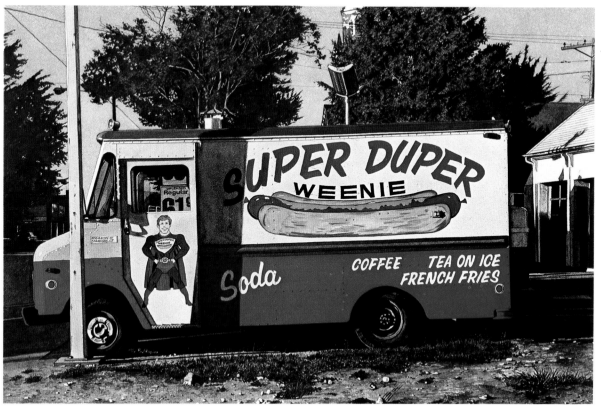

SUPER DUPER WEENIE
Watercolor, 15 × 22″, 1976
Elena and Andrea Brentan Collection, Rome, Italy

Following the tradition of the traveling lunch wagon, and Hickey's, hot-dog trucks in all styles and sizes dot the New England roadside. Many are little houses mounted on trucks, with slate roofs and shingle siding; some resemble the backyard-variety doghouse. There are more on Long Island than anywhere else in the country. Super Duper Weenie was parked in Norwalk, Connecticut. No one was around, so I never found out how super or duper their weenie was.

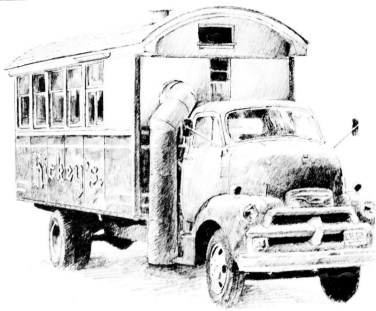

HICKEY'S
Pencil, 7 1/2 × 6″, 1976
Collection of the artist

"Hickey's" joins the diner to the tradition of the old lunch wagon. It was created in 1947 when a new Worcester Diner was placed on a 1947 Chevrolet chassis. The owner, Jack Hickey, starts business at 5:30 A.M. and continues until 3:30 P.M. He then moves his diner from a vacant lot to the Taunton, Massachusetts, Common, where his son takes over until the wee hours of the morning. "Gillies," in Portsmouth, New Hampshire, is another truck-pulled Worcester Diner.

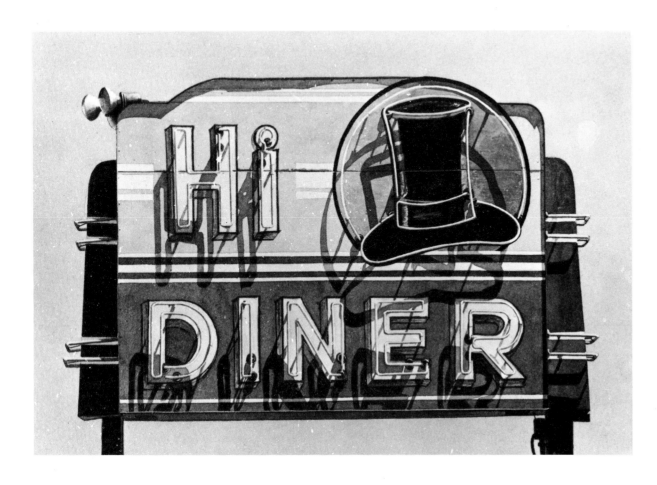

HI-HAT DINER, *Watercolor, 9 × 14″, 1976*
Mr. and Mrs. Dennis Schmidt Collection, Kansas City, Missouri

Hat—as all-time ceremonial costume, the top hat runs neck and neck with the crown. Cleaners, bars, nightclubs, cafes, motels—almost every commercial enterprise has used the top hat.

The word-picture alliteration has something to do with separating the diner's usage from other usages. There was not enough room on the sign for the spelling HIGH; take off the G and H and there is also a subtle, but simplified, greeting hello. Is this why the diner owners didn't use "Top Hat"—word picture? Perhaps there were other "Tops" diners in the general vicinity, and they didn't want any confusion.

ALICE AND THE HAT
Watercolor, 10 × 14 1/2″, 1974. Private collection

"Alice and the Hat" still stands in its prominent location in Worcester, Massachusetts. Unfortunately, today it's a bricked-over real-estate office. Sob. I ate there a few years ago. It was an old Worcester diner that was sagging with age, the typical, convivial diner meeting place. I felt like a stranger; tight conversation was going on, and I soaked in every moment of it.

I'm sure there are many stories about naming the diner. It probably went through a dozen names or more. And a few locations, too. Early diners moved around a lot as neighborhoods grew rapidly during the late teens and twenties.

Alice ran the diner, and her husband, a reporter for the local paper, was known as the "Hat." I guess he was one of those guys you meet who wear some kind of hat that looks as though it never came off their heads—glued to the hair which is glued to their heads (they never get haircuts). These are the same sort of people who have cigars stuck in the corners of their mouths which never come out.

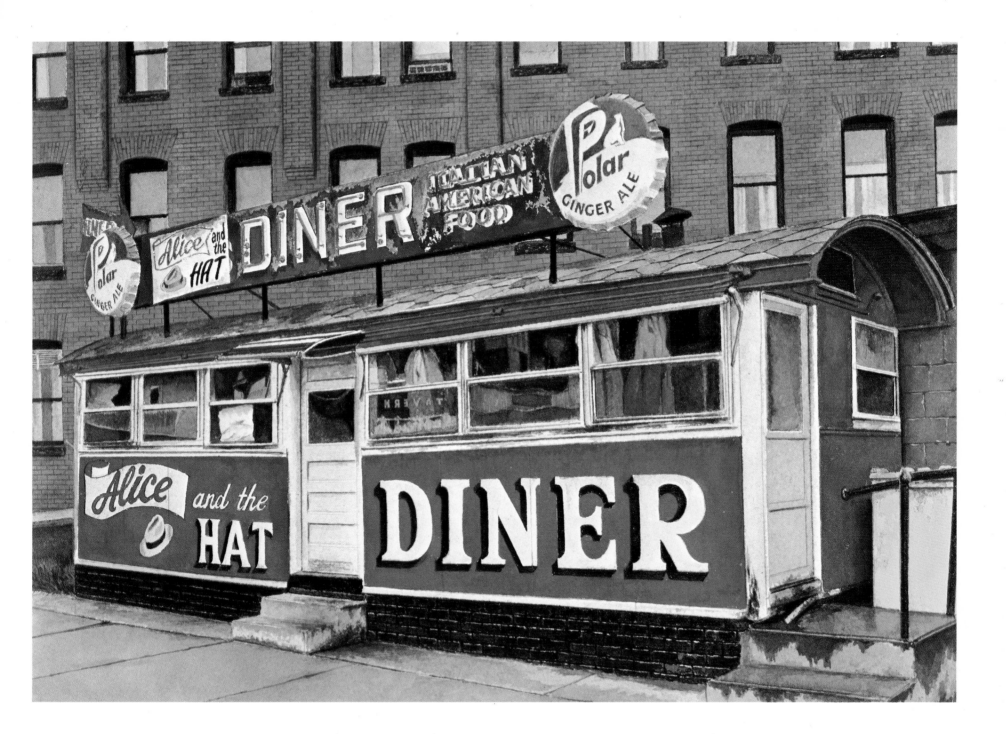

The real ART'S DINER is in Worcester, Mass.
This is what happened when Art re-deco-rated it.
My fantasy, of course. Actually the redecorated
version of Art's is a la Colonial.

READING DINER
Oil on canvas, 42 × 66", 1975
A. Haigh Cundey Collection, Essex Fells, New
Jersey

It was early spring; Dick Gutman and I had
decided to take a stroll in the diner country
around Boston. We rolled into the main street
of Reading, and the diner greeted us like a glass
of fresh orange juice. I was enjoying what was
going on with the three guys hanging out. It
reminded me of Holt's Cafe. *What were they*
talking about? The pancakes? The prom? Or last
night with Patricia? Where were they going to
go when they split from each other? I thought of
the Majestic: bicycles were called bikes; now
motorcycles are called bikes. Hanging out.
Goofing. Doing nothing. Me and my bike.

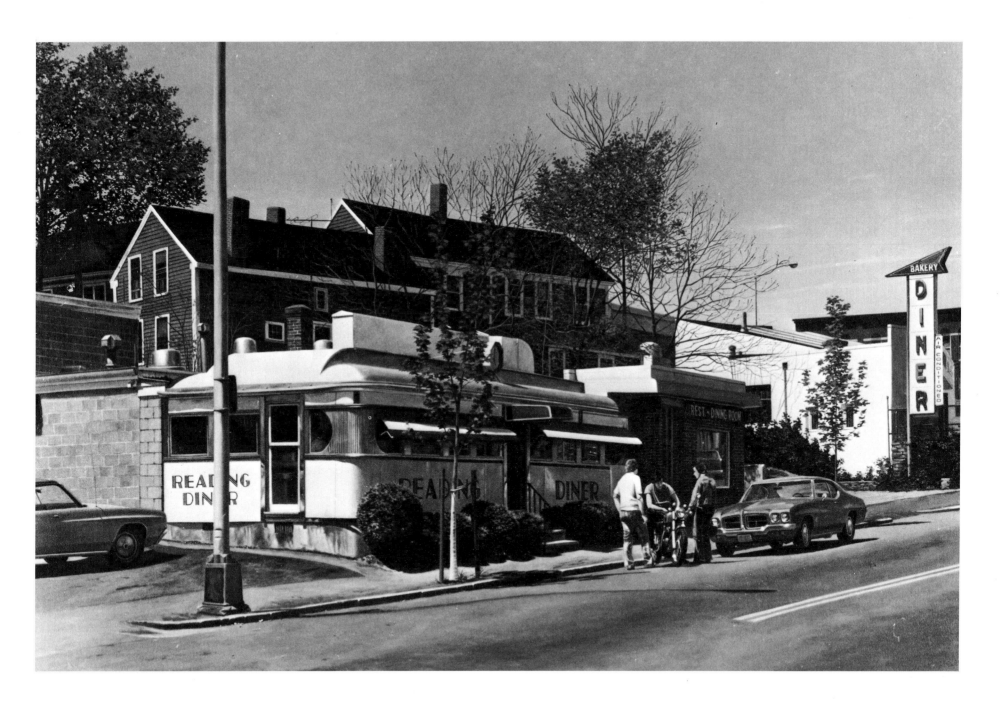

DINER, *Watercolor, 11 3/4 × 8 1/2″, 1974. Lois Auritt Collection, New York*

Diners are loaded with graphic elements. (Art directors like diners; many are used in TV commercials.) A study of close-up interiors and exteriors could fill another book. The fascination comes from all the materials and textures and colors. They all unite with each other. It's properly called dinerhesiveness.

Opulent filigree lettering; pastoral scenes illuminating the owner's name; scrollwork fancily painted in gold and crimson and azure blue: the early lunch wagons in their circus-wagon-spectacled outfits. Someone should recreate this affair of visual orgasm. On to reality, and the close-up wonders that happen with wood; shiny, mellowed caramel wood contrasting white porcelain with chrome hinges. Glimmering, shimmering stainless steel—inside, outside; wrap over and under, in and out. Mosaic inlaid tile in all squares, rectangles, hexagons, octagons, repeat, repeat, repeat. Texture frenzy, zig and zag. Color pink. Green. Burgundy. Gray and Blue and Tan and Red and Beige. Yellow and White and Caramel and Beige and here comes Salmon. Ohhhh Salmon. Watch out, here comes glassyglassbrick. Thick Glass Brick. Thick Brick. Glass. Counter marble. Creamy marble. Black marble. Gold-flecked Formica (like Wanda Waitress's hair left over from Saturday

night). Formica, ruler of the table tops, and counter tops, and the rooftops. Here comes stainless—only less stain.

Time passes and diners grow up into catalog-picture monsters (like their menus). Phony new half-brick. Phony old half-brick. Phony stone. Real stone. Grotesque tile. And those eagles facing left, facing right. The Ionics. The Dorics (they're from North Bergen). Mediterranean sealandscapes. Spanish-mosque. And flocking. Red on red on red flocking. I walked into a new texture palace on Route 17 and was greeted by a Madam. That's where diner graphics have gone. I can see it now: blazing neon, red-and-pink fiery neon, "Brothel Diner, We Never Close."

That's where diners are today. They don't serve food, they serve theme. They serve plastic-graphics. They serve shiny vinyl.

SALLY'S DINER
Oil on canvas, 30 × 48″, 1974
Sol P. Steinberg Collection, New York

Sally's was somewhere outside Montreal. Even though it's not American, I was compelled to paint it. It's because in spirit it had a past life somewhere in Los Angeles, around 1942.

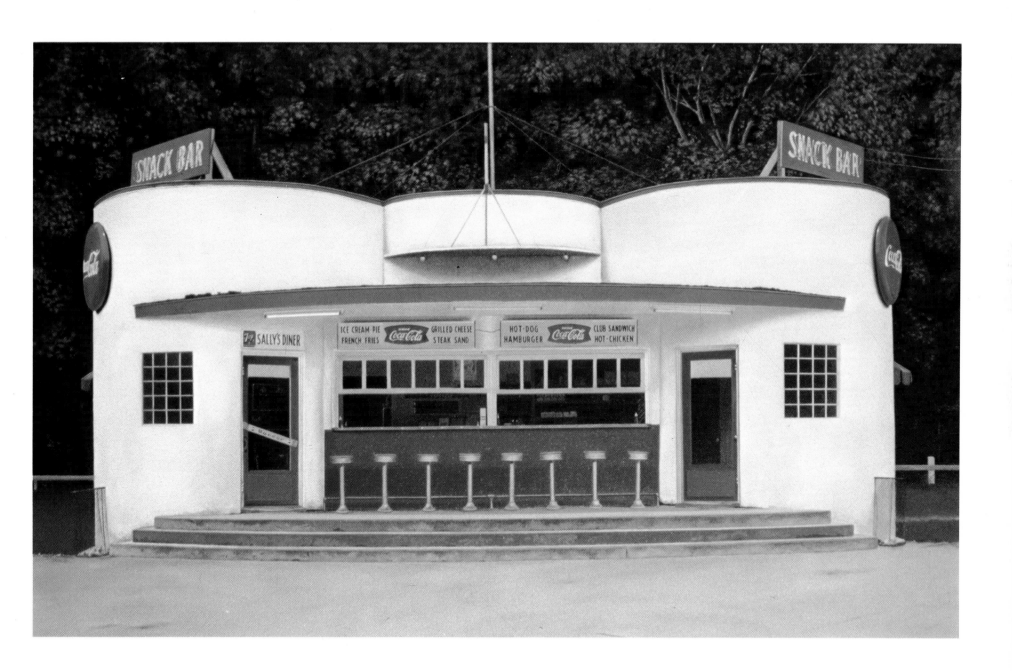

Fantasy diners come from inspirations. This one came from the Zep Diner. It was a zeppelin shaped diner in Los Angeles — where else? Sometime in the 1940's.

MODERN DINER
Watercolor, 10 1/2 × 16", 1974
Courtesy O.K. Harris Gallery, New York

Driving through Pawtucket, Rhode Island, I was surprised to see the Times Square Diner; it was a nice, clean, and simple diner, and looked home-made (aquamarine porcelain separated from a brick building on one side and the black Vitrolite front of another bar and grill on the other side). Around the corner was the Modern Diner. All this was happening too fast for me. I took a deep breath. I photographed the Modern from every conceivable angle, interior and exterior. I have yet to get to the Modern in a big way. The time will come.

The Sterling Dining Car Co., in Merrimac, Massachusetts, placed ads for their beauty in Diner *magazine, promoting the diner and comparing it with the speed and luxury of trains and airplanes. The ad pictured both and stressed that the design would attract more customers and promised double profits. Ironically the Sterling people were owned by the J. D. Judkins Co., the famous coachbuilder who made many custom "streamlined" bodies for some of the great classic automobiles— Duesenberg, Packard, and Lincoln. When business fell during the Depression, the company went into the dining-car business.*

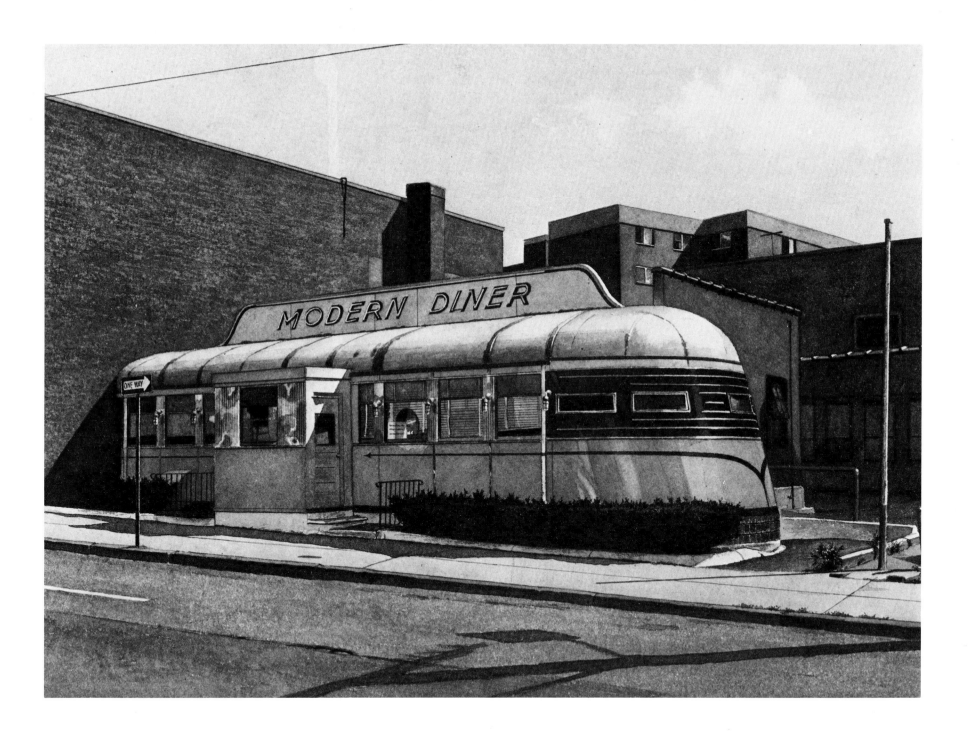

C & C RESTAURANT, *Oil on canvas, 42 × 66″, 1974. Collection of the artist*

The "C & C" is a good example of the use of clean, smooth, inspired materials. I don't know the date, but I'm sure it was an old restaurant that went modern around 1938. Part of my relationship with the C & C is that I have no information about its past. I'm in the now with the C & C.

Enter the mystery and all the ambiguities that go with it. Who are "C" and "C"? How old was the original restaurant? Does the interior match and equal the exterior? I compare the C & C to a hidden person. One only sees the surface and can't get deeper. I'll go back and reacquaint myself with the C & C and hope we can get closer.

As I was leaving that day in Waterbury, Connecticut, I stepped back and something happened. The library next door was independent of the C & C and the C & C of it. Such individuals, those two. The library was built slightly aslant of its property line (it has a bit of a limp); the C & C proud, faintly aware of its passed fashion; the yellow Chevelle a passerby taking both for granted.

I have to take a break from diners to pay homage and honor to places like the C & C Restaurant. I reflect on the "why's" and simply realize, then decide, it's all part of the process— the deeper reality of the world in which we live.

I'm not in favor of quoting people I read and like, and all that. However, I can't pass this one up from my friend John Dewey in Art as Experience.

A work of art elicits and accentuates this quality of being a whole and belonging to the larger, all-inclusive, whole which is the universe in which we live. This fact, I think, is the explanation of that feeling of exquisite intelligiblity and clarity we have in the presence of an object that is experienced with esthetic sensitivity. It explains also the religious feeling that accompanies intense esthetic perception. We are, as it were, introduced into a world in which we live our ordinary experiences. We are carried out beyond ourselves to find ourselves. . . .

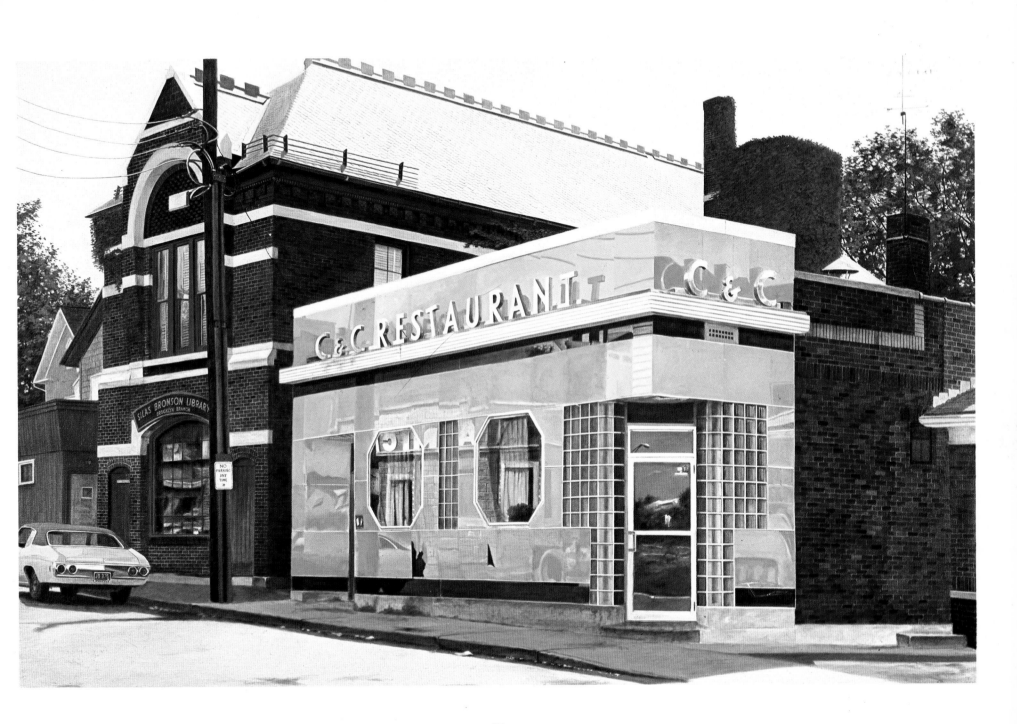

went to college in the late fifties at Auburn University in Auburn, Alabama. (I always thought I'd go to the Royal Academy in London, and the reasons I chose Auburn are a separate story—a study in polarity.) I sped through Auburn years later (several times on my way to New Orleans in the early sixties), my sensibilities not keenly alert, and with some residual anxieties about my four-year stay there. I didn't stop; there was *no* sentiment.

After seventeen years I finally decided to make a pilgrimage; I had changed, and I was curious. Auburn is a lovely All-American college town, and I hadn't appreciated it as much as I should have. I remember all the hooting and hollering in 1957 when Auburn was the number one football team in the country. I couldn't have cared less, for Auburn is also the home of Roy's Diner.

Roy's was a cozy eight-stooled, four-boothed nook where I spent many breakfasts and lunches—too many dinner-evenings and early morning breakfasts. I practically lived in Roy's Diner, along with a lot of other students and locals.

I had learned earlier that the diner building was still around, but it had last been a real-estate office. I also learned that Roy was still around, somewhere, but no one knew exactly where. I had to search him out;

I wanted a photograph of Roy's Diner in its brighter years. The quest was on.

The back roads from Atlanta to Auburn were important for me; I learned this truth many years later. To get into the spirit of a pilgrimage I had decided to drive from where the South starts: Virginia, then through Tennessee, through Alabama, and, finally, War Eagle country—Auburn. There it was, Auburn's only eyesore: a decapitated piece of stucco, a derelict building, hardly a trace of what was once a diner. It had been eaten up and it was dirty and crumbling. I spoke about Roy's to some townspeople, but they had never noticed it; others barely remembered it. It wasn't *that* far into the past.

I went back on a second visit to pay my respects. I had the murky feeling of visiting a gravesite, looking at the headstone of a loved one, gazing down, as through gauze, feeling mouth tension, reflecting, tearing slightly, turning and leaving. I was about to bid farewell forever when I noticed over to the side a ghost-gray piece of metal peeking through some overgrown underbrush. I bent down, pushed the hairy green aside, and there were the remains of Roy's sign. I saw the ghost, the letters, all nine of them. They came into focus through the sun-bleached blue-gray paint, white as could be, those nine letters: ROY'S DINER. Then they quickly disappeared. It was a matter of seconds.

That sign had to be rescued and be put into a proper home. Mine. No! It needed to remain there, snoozing in the underbrush.

After several phone calls and a couple of days' waiting, I finally got hold of Roy Hancock. He was living in Brantley, Alabama, about a hundred miles south of Auburn. Roy had just installed a phone about a week before my arrival, but he was difficult to reach. I kept calling and calling. When I finally spoke to Roy it was a thrill. He was in ill health but able to talk; however, not too eagerly. He didn't remember too much; he sounded worn out. He told me he opened the diner in 1953 and closed it around 1969 or 1970. We talked about his specialty: the steak sandwich. Boy, was that good; a culinary delight (to a college kid in Podunk). It was a veal steak with a golden (no menu jargon) crust; although deep fried, it didn't taste fried. It tasted deep, and crunchy. The bun was large enough to fit the steak, toasty, and also golden (my favorite menu word: Golden).

I asked Roy more questions but he wasn't too responsive. I couldn't make up my mind to drive down to see him. Roy said he was never home, and I asked him what he did these days. He said nothing, that he had had two heart attacks and couldn't work. He didn't want any visitors, and I believe he didn't want to be reminded of the past.

I pursued with more questions. I was determined to find a picture of the diner in its earlier days. Roy had none. I was very disappointed.

"Are you sure, Roy?"

"Naw, I never had any pictures made."

Letdown again.

"Where were you before Roy's? Did you have another diner?"

"Yeah, I was a cook in Gu-Gu's, in Columbus [Georgia]; it was a trolley."

I was drooling.

"Do you have any pictures of Gu-Gu's?"

"Naw, sure don't."

"How did Gu-Gu's get its funny name? Who was Gu-Gu?"

"I dunno, it was just Gu-Gu's."

(I learned later that Gu-Gu's was torn down and that a large and very good Greek restaurant had been built on its site. Gu-Gu's restaurant later burned down. Today on the same site there's a car wash appropriately named Gu-Gu's. I wonder if they sell sandwiches and coffee while you wait for your car?)

Obsessed as always, and playing investigative reporter, I started searching for a picture of Roy's Diner. I had one already picked out in my fantasy, and I was determined to get it. The local newspaper morgue was the logical starting place; I went through the files, back issues from the

period, ads. Nothing. At the Auburn library there was a photo archive. More search. Nothing. There were no ads for Roy's in the yearbooks. I went to the campus photo service and searched their files. Nothing. I talked with a few townspeople, including a druggist who remembered me after all those years. He put me on to the son of the retired local photographer. A glimmer of hope.

After locating this chap, who had moved away from Auburn, I felt I was on to something. However, all he could talk about was his recently amputated leg, and all the portraits he took, and all the parades he shot, and all the football players—and all the negatives he had burned. I sank. He said he couldn't remember taking a picture of Roy's. Maybe it was in the background of a passing parade?

No pictures of Roy's Diner. But the trip wasn't wasted. It's all a part of the process, part of the quest. I'll find a picture of Roy's.

I drove back to Atlanta, slowly, the same old route. There is now an Interstate to Atlanta, so I had more of the old road to myself: Opelika, West Point, LaGrange, Newnan. I stopped for my Dr. Pepper and bag of Tom's peanuts at one of the many gas station–general stores I used to frequent. Those roads were important to me, just like all the roadside eateries, and gas stations, and churches, and town squares. They were starting to supply nourishment when I didn't know it, just like feeding a fetus before you know you're pregnant.

I like the idea of carrying my unconscious and conscious with me as if they were in a notebook—but separated by dividers. The edges of my pages were frayed from mental activity, and traveling, and coming back to starting points, and just doing. I carry the notebook along with me wherever I go. On its pages are the various combined dramas of obsessions, impressions, moods, emotions, sensations.

The pages are looked at as you would a magazine, sometimes casually and sometimes with intensity, and they are dealt with. I take the notes and put them into my paintings. I call the notes CON and UNCON, and see them fuse with one another like amoebas under the microscope. They take on new meanings with deeper significance.

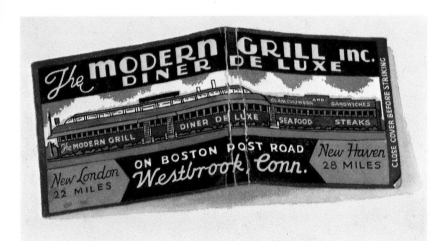

THE MODERN GRILL INC. MATCHBOOK
Watercolor, 16 × 19″, 1977
Collection of the artist

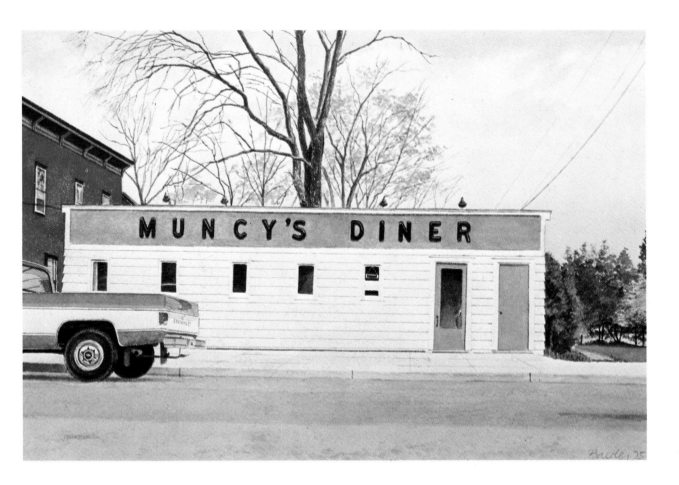

MUNCY'S DINER
Watercolor, 8 × 12″, 1975
Courtesy O.K. Harris Gallery, New York

One of those unclear mornings somewhere in New Hampshire. Out-of-it-blank-disconnected-feeling (even with two cups of hearty coffee). Muncy's is easy to miss. I stopped for a light—red-light-dozing. My heavy head slumped to the left. Hello, Muncy, you look the way I feel.

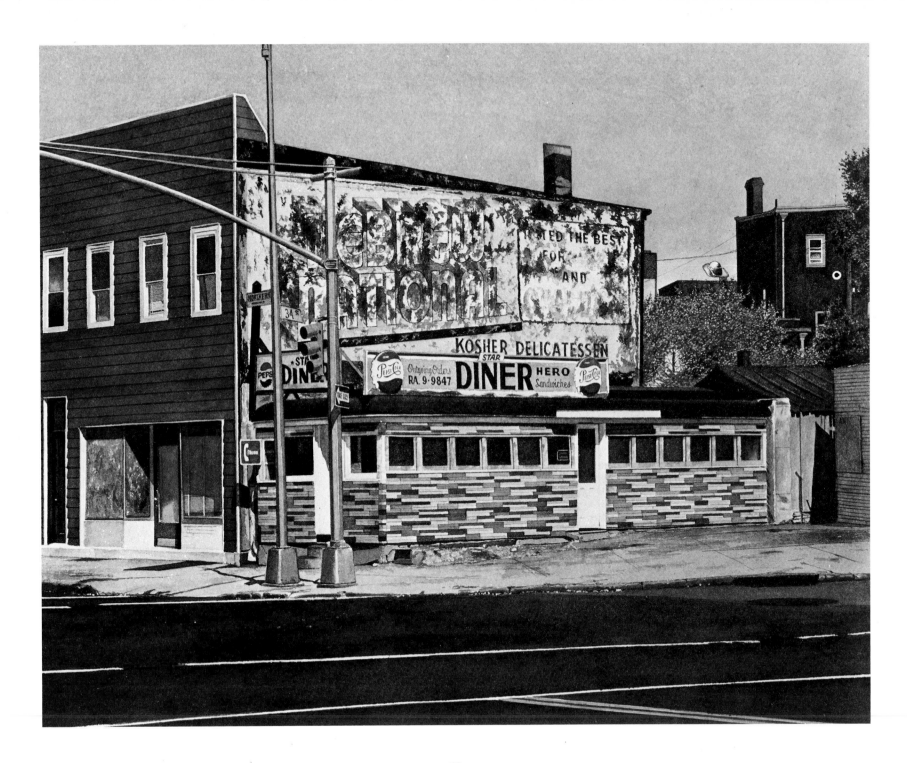

The Deli-Diner was designed exclusively for the Catskill Region and the Miami Beach Region.

STAR DINER
Watercolor, 11 × 16″, 1976
Barbara and Bruce Berger Collection,
New York

The Star is on Northern Boulevard in
Queens, New York. It sits quietly on the
corner, aging with its flaking wall partner.
The subtlety of the Hebrew National sign
does not have any relation to the name
"Star." Verbal and visual anachronism.
Yet, wall and diner are relatives, they stand
alone, but lean on each other. Early
remodeling in mauve, and pink, and gray.
The double-knit look. I continue to drive
by the Star and expect to see a fresh coat of
paint on the wall and hope it never happens.
Let the entire corner fade gracefully.

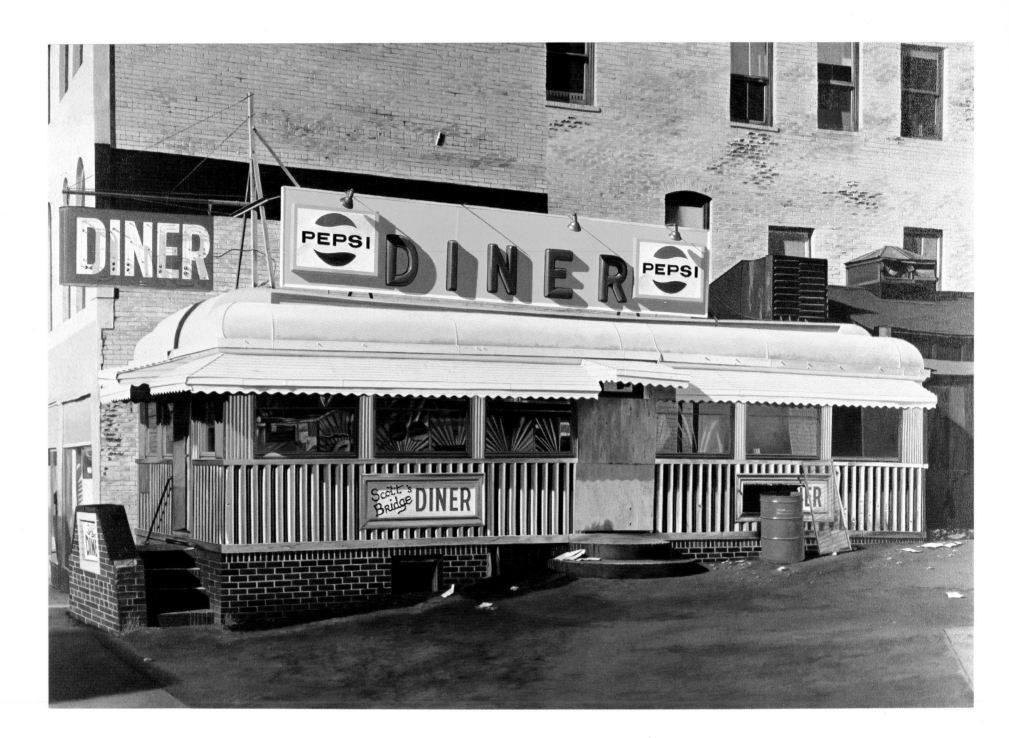

SCOTT'S BRIDGE DINER, *Oil on canvas, 60 × 72″, 1974. Private collection*

The Scott's Bridge was one of the earlier diners I discovered. At the time I was not noting my locations. In fact, I remember well that in the embryo stage of looking for diners I was very nonchalant. I'd see a diner, stop to take a few pics, then move on. Of course I then had no idea I would be painting them full time.

I followed-up to do the painting two years later, and while painting I got into an altered state of consciousness—something I had not experienced since beginning to paint.

The bricks were being laid with mortar and painted. They then peeled. The sign was being painted by a sign-painter (I fulfilled my fantasy),

not a painter of diners. I was inside the closed diner looking around the dilapidated interior, looking at the fluted stainless-steel backboard. I hammered that piece of plywood in front of the door; it wasn't painted. On my hands and knees I got down on clean cement, felt the dirt and the oil drippings. My paint spilled oil. I was the neon man adjusting the sign, installing the tubing. I rolled the barrel into position and then stenciled the letters as I was signing the painting.

I got inside this painting, and it was pivotal for me; a new experience was happening, and it was bigger than painting, and bigger than me, and the whole world.

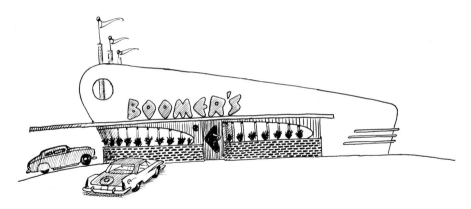

"BOOMER'S" OPENED FOR BUSINESS IN EARLY 1955. IN 1962, WITH THE TWIST CRAZE
AND A NEW WAVE OF ROCK + ROLL MUSIC, BOOMERS OPENED THE BOOM-BOOM ROOM
FOR DANCING, BASIC FRIVOLITY, AND GENERAL HANKY PANKY. IN 1964 A MALCONTENT
FOR BOOMERANG STYLE EXISTED, SO THE OWNERS RESTYLED TO
KEEP UP WITH THE TIMES. THE ZIG-ZAG THEME WAS POPULAR,
AND THE ZIG-ZAG MAN WAS EVEN MORE POPULAR—IN FACT, HE
WAS USED AS A SECONDARY MOTIF IN THE ZIG-ZAG ROOM.

AMERICAN GRILLE, *Oil on canvas, 30 × 48″, 1974*
The Belger Family Collection, Kansas City, Missouri

Driving north on Route 5 one hot July afternoon with a friend who had momentarily taken ill, I passed the American Grille but couldn't stop; so I snapped a few pics through the imaginary lens on the side of my head: memory bank. The American Grille was extraspecial.

Returning after a few days, I realized the place had to be painted even though it wasn't a diner: it typified commercial architecture during the late 30s and early 40s. Tiny pebbles were embedded in the rosy stone, like a mosaic that wasn't. What kind of stone was that? It was different. The round windows, big black eyes of a building focusing on itself. And me. Modern. New. American. Grille.

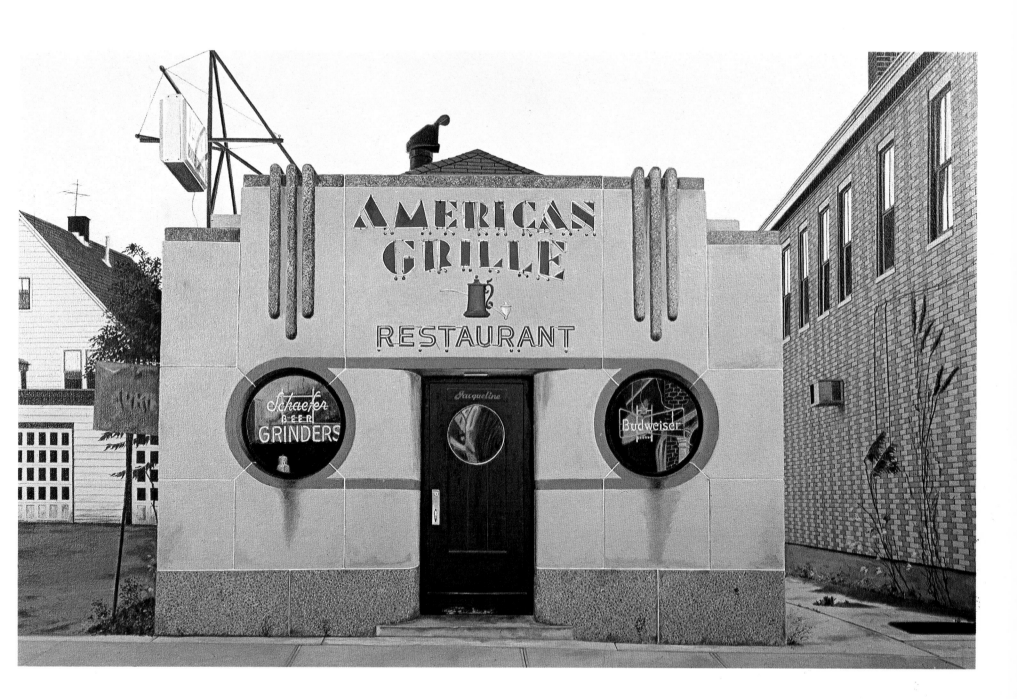

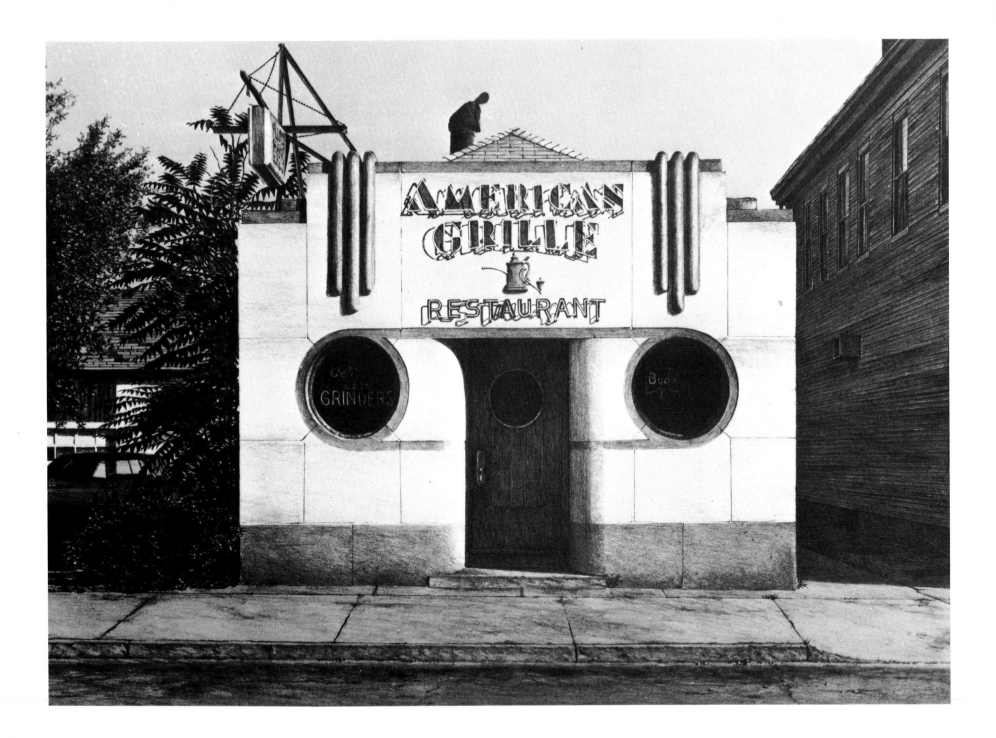

AMERICAN GRILLE
Lithograph, 18 × 24″, 1975

I never like to repeat images. However, the American Grille had always been hypnotic to me. As with many diners, every time I passed it something physical happened to me: it was like the rush of adrenaline triggered by anger, fear, or, in this case, joy. I wanted to do another painting, but at the time I really needed to experiment in another medium. I started to do a series of drawings and was surprised to see that they all looked the same, the same frontal presentation. It was evident that if I was going to repeat myself a lithograph would be a better solution. Since I had never done a lithograph before, I thought it would be fun. So I visited Master Printer Jack Lemon at the Landfall Press in Chicago, and we proceeded: he set a lithostone on a table, and I started to draw.

TOWN SQUARE DINER, *Watercolor, 6 1/2 × 8″, 1974*
Tony Atkin Collection, Philadelphia, Pennsylvania

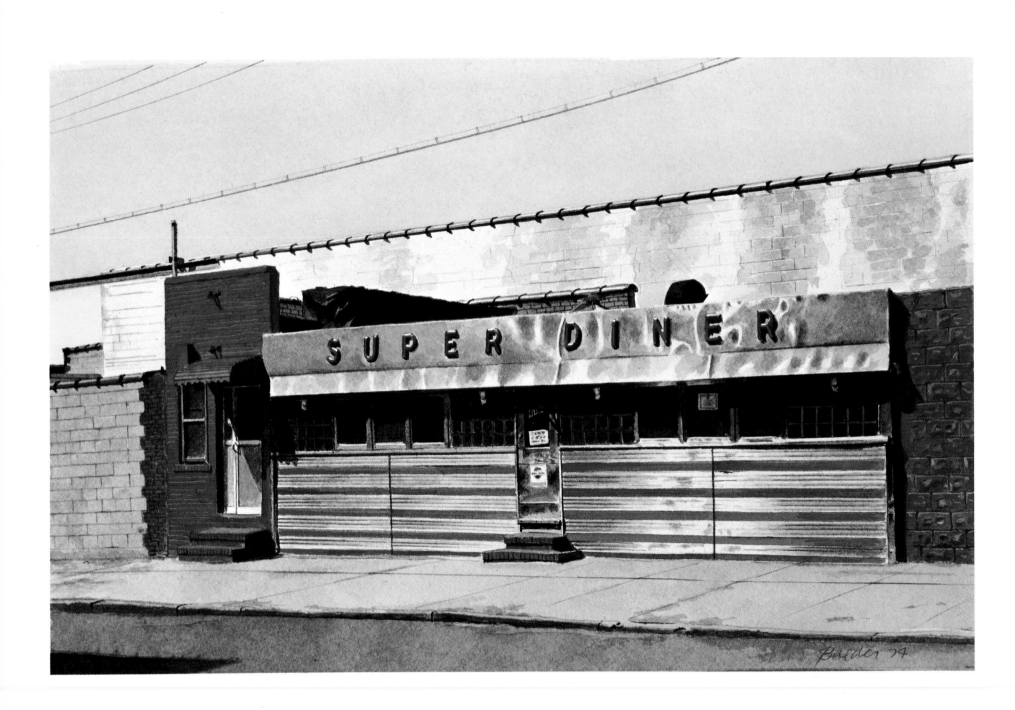

PRIVATE H-MOON SUITE

POOL + SAUNA

SUPER DINER, *Watercolor, 12 × 15″, 1974. Richard Brown Baker Collection, New York*

Brooklyn, New York, is reputed to be either the fourth- or fifth-largest city in the country. It depends on who's doing the statistics that day. It's a mighty huge area, and many eateries were around during the diner heyday. Many still exist.

It's an easy undertaking to get lost in Brooklyn, and getting lost is a lot of fun for me. I find more diners while getting lost (but usually not in Brooklyn). Well, I was doing one of those psychic trips on myself, thinking about my need for a diner. (This is what happens when I get lost— diner-discovery as reward.) I passed a couple of heavy-duty wrecker trucks, and I was thinking to myself (no kidding, now): "I need a super diner just to get me out of this mess and make it through the day. . . . Eh, may as well forget it." Stopping at a light, I rethought my dialogue: "I never use the word 'super'; that's for superficial people, and that's why 'ficial' is prefixed by 'super,' play on words and all that. . . . " Stream of consciousness, wandering, looking. The light turned green; me feeling lost; two blocks up to the left there was a glowing light, and it was reflecting metal. I got closer and hee-hawed to myself as I answered my own question as to what that glimmer could be.

AMBASSADOR II
Watercolor, 9 1/2 × 10″, 1977
Courtesy Morgan Gallery,
Shawnee Mission, Kansas

The crown is the universal symbol of man's
cherished expectancy for the future. We all crown
ourselves in subtle, and not so subtle ways:
Homes. (The palace, and there are many "Palace"
diners.) Automobiles. (Horses and Power.)
Jewelry. (Look at me.) Perfume. (Smell me, I need
attention.) Fads. (I can't accept myself, so I'll
join all the others.)

I wanted to meet the owner of the Ambassador
II and find out how he really felt about himself,
and the history of the diner's naming. He had the
same spirit as "King's Chef," though less crafty.
I love the curving arrow pointing to his identity.
(Who and where is Ambassador I?) "Look,
everybody-passing-by—I am king and I know it."
The afterthought of "time to eat," I speculate, is
a carry-over from earlier signage. A message
reduced to nothing.

EMBASSY
Soft-ground etching, 8 3/4 × 13 3/4", 1975
Printed by Master Printer Donn Steward,
Halesite, New York

American food can get tiring. Diner food, too.
So, we all go the ethnic route since it has virtues
for the palate.

Same goes for working and experimenting in
other mediums. It's refocusing, like having
another hand and another set of eyes. The
richness of oil and the immediacy and magic of
watercolor are not enough. Part of the quest
should be carried over in the latitude other
mediums offer. I like hot peppers, and barbecue,
and hot chili. Some people don't, but I've got to
have them once in a while to keep going.

THE PULLMAN, *Oil on canvas, 60 × 72", 1974*
Mr. and Mrs. Robert Mann Collection, Shawnee Mission, Kansas

Collectively, there are more wonderful diners around Boston than anywhere else in the country. The Pullman was in Arlington, Massachusetts, a suburb north of Boston. The name itself means a lot to me: a tribute paid to the famous coachbuilders of railroad passenger cars. The naming of diners follows the tradition of Pullman coaches and dining cars. Cars were named in honor of some well-known personality or special place. Dining cars were named for famous restaurants. Pullman became a household word in most families whether or not they traveled on trains. Pullman—another passing name in our cultural vocabulary.

For some unknown reason, probably my usual compulsion for turning corners (rounded glass-brick ones, of course), I wasn't satisfied with the cold February light captured in an earlier photo.

It was right for the painting, but I didn't know it at the time. I proceeded to make a trip to Boston so I could reunite with the Pullman, to get a better feel for this classic diner.

Dick Gutman and I made the short trip from Boston to the Pullman. About two years had passed since my last visit, and I was excited: f-stops poised, eyeballs nervous. Tension grew as we pulled up to its site. Empty. Gone. We looked at each other speechless. Stunned. Very quickly we learned that the Pullman had been demolished. On the site a cardboard bank was being erected.

The Pullman was virtually mint, an untouched '41 Worcester diner. We drove off aching and speechless and asking ourselves—why? Silently as if in prayer. Why?

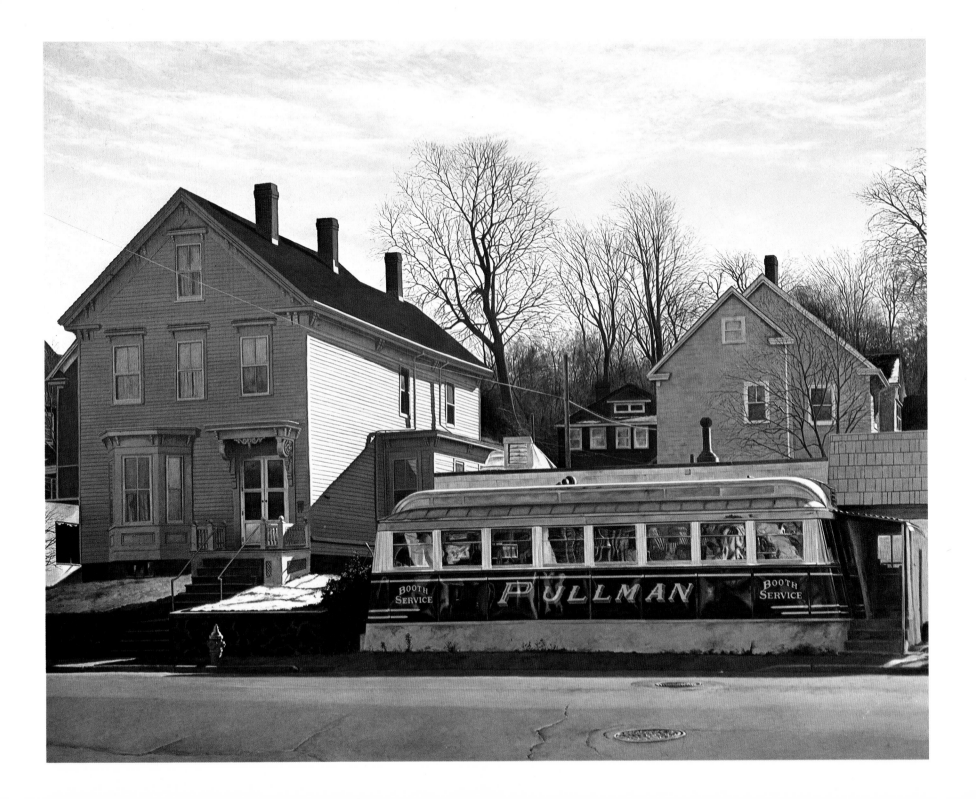

KING'S CHEF
Watercolor, 13 × 19″, 1976
Courtesy Capricorn Galleries, Bethesda,
Maryland

*I was on a remarkable high one afternoon in
Colorado Springs, Colorado, taking some pictures
of an amazing sight: an aqua stucco gas station
complete with trailer court companioned by an
"Irish" green, yellow-trimmed diner-turned-
bakery. A combination of roadside excitement. I
located the owner of this triple whammy, and we
chitchatted about diners. He said, ". . .there's
another diner down that street; and you take a
left down that street and you won't miss it. . . ."
He wasn't specific, so I didn't know what to
expect. I saw two primer-gray '37 Ford coupes
parked behind each other, identical twins, and
figured it was a good omen.*

*This Valentine diner was an extremely fine
example of an owner's imagination and fantasy.
As I checked out this toy wonder, I questioned his
attitude about the name: King's Chef. Why does
he think of himself as chef to the king? If he had
more personal pride he would be the king. And
then he could have named the diner "King
Chef." A man's diner is his castle.*

I moved from Atlanta to New York and started to frequent rural flea markets. This was in the early sixties and before the "antiques craze." At the time the sleeper and "In" market for all the hip New York dealers was in Englishtown, New Jersey, about an hour and a half from Manhattan. You had to be there early to get your goods—at least by 6 A.M. My good friend Kenny Kneitel and I would religiously go every Saturday, usually getting a sleepy start at 4 A.M. (which wasn't too easy after being out all night bending elbows). All the sharpie dealers were there. You could spot them; it was like a race to see who could out-buy the other. As the morning got started the local dealers rolled in and displayed their wares. There was a Farm Security Administration quality about the place.

The wise people were out by 10 A.M., when all the folks from the neighboring communities started to show up in droves. Besides, all the goodies had been swept up by the dealers from New York. Bargains could be had literally by the carload. Those *were* the good old days.

At Englishtown I started buying postcards, cards I never liked before, but my sensibilities were changing. I bought all kinds of images, most of them "graphic." At the time I was an art director with a large advertising agency, and art directors get hung up with anything "graphic." It's an extension of their design-oriented ego. The cards were from different periods, ranging through the twenties, thirties, and forties. All American in origin. These cards had been thrown into old boxes. Junk to these dealers; they got them in attics and basements and took a "who needs 'em, but maybe I can make a few cents" attitude. These cards were cheap and plentiful.

There were some hard-core flea markets in New York, and I saw dealers with lots of postcards, except these were organized, and broken into categories like states, and subjects, and special dates, and postmarks. They were more expensive, but still reasonable. (Today the postcard market is beyond ridiculous.) I bought more cards and more images that appealed to me for reasons I wasn't aware of at the time. They were just "graphic."

Little did I know that these postcards would be a fresh starting point for me. I'd look through them picture after picture, like looking at magazines (. . . the images from looking out the train window when I was a kid). A pattern started to emerge, and I was beginning to enjoy particular images, and they were just beginning to touch me somewhere in my psyche. They were talking to me, but I wasn't able to talk back. These images were gas stations, tourist courts, motels, restaurants, bus stations, trailer parks, small-town street scenes, commercial buildings, and, of course, diners.

I met an authentic postcard dealer; I mean this guy was in business

to sell just postcards for a living. I paid him a visit and bought more cards, and more cards. I was hooked. Postcarditis. I joined postcard clubs and went to postcard shows. (A subculture of vultures.) I placed ads in various postcard club newsletters and collectors papers. More and more postcards came my way, and it was overwhelming.

Like a baby, I was going through the purest form of infantilism: gimmee, gimmee, more, more. Cards started coming in from all over the country. I would buy them "on approval," which means that the customer picks what he wants from a batch of cards and returns the unwanted cards, paying postage both ways, and, if necessary, insurance. What a marvelous system for receiving postcards and acquiring postcard friends through the mail. They are a separate breed, and worth writing about. I have kept all my letters and wish someday to do a book called *Letters to a Postcard Collector*.

I was getting packages in the mail almost every day; sometimes there were bundles, and even boxes full. The idea of collecting *en masse* had overtaken me, and I realized that I really needed to know the cards individually. I started to look at them. One by one. One by one. It took time, and then I began to *see* them.

SANDWICH GRILL
Watercolor, 9 × 13", 1975
Collection Detroit Institute of Fine Arts

*The Sandwich Grill is a diner in concept, but the
main attraction to me was the architectural
contradiction. The simplicity brings to mind a
very general observation regarding the use of
materials to express the concept of "modern." (I feel
the invitation for specifics here, but shan't accept.)*

*In the 30s, clapboard and brick were considered
"old-fashioned" for commercial buildings. They
were warm in feeling, but depressing because of
the texture and color. As a social force, the
Depression compounded this attitude. Clean,
smooth, and bright materials would have a
healing effect on the environment and, hence, the
society as a whole.*

*Plain porcelain, Vitrolite (the most popular
material—glasslike and available in a wide
variety of colors), Bakelite, glass brick in all
sizes, chrome, stainless steel: these materials
were favored by architects, interior designers,
and other people involved in the new look. Art
Deco-inspired, perhaps, but not Art Deco, as so
many people are led to believe.*

*Today, the late 70s, the opposite holds true, but
the reasoning is similar. We live in a highly
mechanized society. Our commercial environment
is flat and cold. There's no personality, character,
or originality such as prevailed in those years in
the late 30s. Solution: "Warm," "Homey," "Country"
(back to nature, to hell with the machines . . .).
So, we have bricks and clapboard revived, stucco,
beams, Spanish tile roofs, shingles. The great
symbol for this overtaking is the neomansard roof.
The slogan for the 70s, the flat, slanted 70s, is:* GO
MODERN, GO MANSARD. *Ugh-ly!*

*The use and prominence of the carriage lamp
is getting as ridiculous as the mansard roof. I
wonder if there's more here than meets the eye—
like, America, wake up and take a good look at
yourself.*

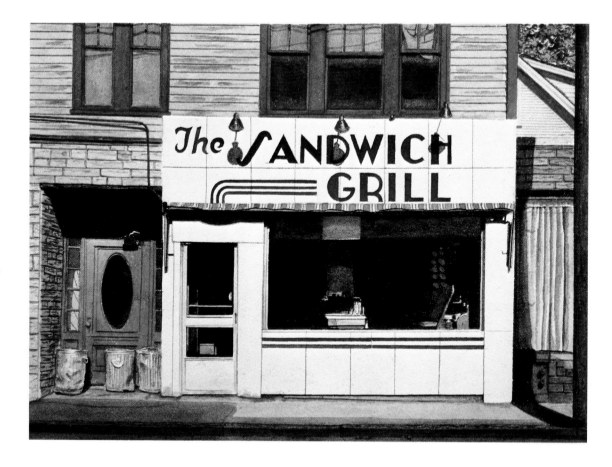

ROYAL DINER BAS-RELIEF
Watercolor, 7 × 13″, 1977
Courtesy Morgan Gallery,
Shawnee Mission, Kansas

ROYAL DINER INTERIOR
Watercolor, 7 × 9 1/2″, 1977
Larry Gutsch Collection,
Lake Forest, Illinois

I've passed the Royal many times. It's across the street from the Maple in Elizabeth, New Jersey. It never appealed to me; except every time I'd pass by, the bas-relief chef on the side would startle me. I was driving back from the White Castle on Routes 1 and 9 in Elizabeth, and it struck me. Visual thud. It was a different point of view. I parked, got out, and studied the place—a bit of the diner wrapping itself around acid white. The un-air-conditioned air-conditioned sign. The tree. Those cars, looking as if they were listening for something to happen in the kitchen. The man in the telephone booth: what's he up to? Is that his dog? Everything fell into place. I was in a mood, and the Royal Diner was in a mood. I didn't

know at the time I would return to the Royal for a more important visit.

I went back to the Royal Diner for two reasons: to investigate the bas-relief and to show the owner a transparency of the painting. I was curious to get a reaction from an owner; it's a nice way to meet and talk diners.

I walked inside and introduced myself to the owner. He couldn't understand my name, and I couldn't understand his. I told him why I was taking pictures of the diner. He didn't react. I tried to explain, but all I got were a few apathetic gestures like a shrug of the shoulders and a twist

of the head. We definitely were not communicating, and from his heavy Greek accent I thought he had just come over. He told me he had had the diner for three years.

It wasn't easy trying to explain to him how much I liked his diner, and how important diners are, and why I paint them. He told me it was a piece of junk. That was his attitude. He repeated himself. I understood; I knew what a rough business it is, especially with the newly remodeled diner smack across the highway: the Maple with its fresh Roman-arched windows, Spanish-tiled mansard roof, Early American stonework, Greek ownership, and American food. Sure, he thinks his diner is a piece of junk. All

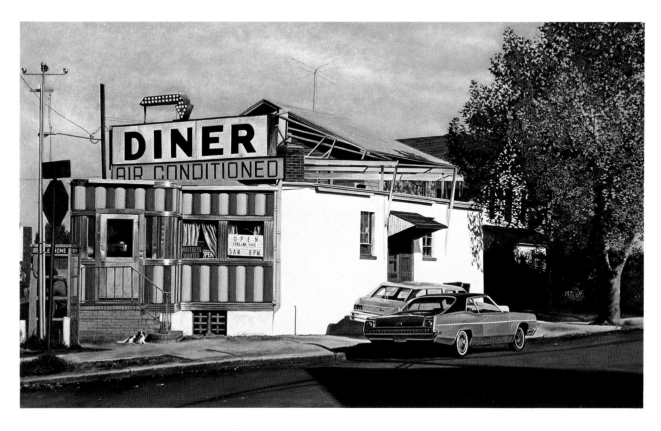

ROYAL DINER
Oil on canvas, 30 × 40″, 1975
Malcolm Goldstein Collection,
New York

the customers go to the Maple. It's new. And fresh. Who wants to go to the old-fashioned Royal Diner anymore?

That's the problem, and that's why there will be no more diners left in a few years.

I ordered a couple of chili-dogs to go, thanked the owner, and started to walk out. As I was making my exit I noticed on all the windowsills dime-store cut-glass vases. Each one had a plastic rose in it. He couldn't afford real roses, but the caring was there. He cared about his diner; it really wasn't a piece of junk.

A random still life, no arranging—a found image. Like all the diners. It touched me as a visual metaphor: that single plastic rose, all alone on the windowsill, too good to be next to napkins and sugar and ashtray. All the hazy passing traffic as its "background."

That Zorba man, hardworking diner-owner who thought his second home was a piece of junk, wasn't telling me the truth. He wanted me to believe that; he didn't want to believe it. He knew that diner was still the "Royal," and he was going to see that it lived up to its name.

The stainless steel bas-relief mounted on the Royal Diner is about three feet high and about six inches deep. Emanating from either side of the relief are five raised rays that spread two feet.

This was the only chef motif around the Royal, and it got lost with the bright yellow and green paneling.

A closer look is scary. This guy is not just another stylized chef. A closer examination of this figure reveals something more: an icon from a primitive culture—the eyes and eyelids, the funny nose and tiny mouth, the oddly shaped hands and split torso. Sure, but he came from the metal shop that made him; someone did a master drawing and it was scaled-up and assembled. This is an authentic piece of folk art in my book, and it is a welcome member of the Diner Hall of Fame.

TWIN DINER—FLOOR
Watercolor, 6 7/8 × 8″, 1977
Private collection

The little frivolous chef is dancing the diner boogie. From the gesture it looks more like the czardas. Knife and fork in hand, he's expressing joy on the job—ready to carve a freshly roasted turkey any moment. The chef motif stars in diner menus, inlaid Formica, chairs, glasses, matchbooks, even light-switch plates. Everything.

THE MAGIC CHEF, *Oil on canvas, 48 × 72″, 1975*
Collection Denver Art Museum, Denver, Colorado

A chef is a universal food symbol. Chief of food preparation. Is chef mother? or father? My first acquaintance with the chef motif was when I was around six years old: the friendly black face on the Cream of Wheat box. I stared at him as the cinnamon-infused warm mush slid around my mouth. I'd always bring the box to the table just to study him (early visual fix).

Chefs appear in all forms, appear everywhere—all sizes and shapes from the finest restaurants to the lowest fast-food stand. At this writing The Magic Chef in Denver, Colorado, is waiting to be taken to Roadside Heaven. Route 85, Santa Fe Drive, which goes south out of Denver, is being widened. Good-bye "Magic Chef Cafe Truck Stop Eats Shop Home Style Cooking." I am happy I preserved you; and people who want to be reminded of the good ol' days on Route 85 can hustle down to the Denver Art Museum and peek hello.

Mrs. Gail Crary was the last owner of The Magic Chef. She told me gleefully that business increased as a result of an article in the local newspaper about my painting of the diner. She said the place had become a landmark. That's good feedback.

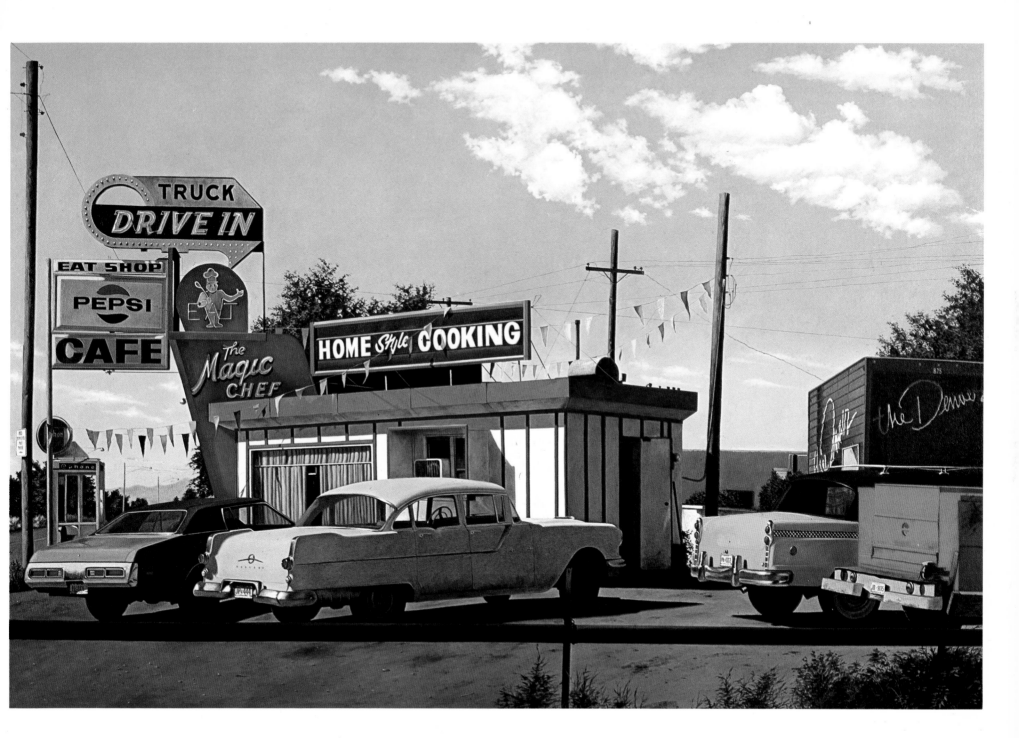

CHATEAU DINER, *Oil on canvas, 30 × 40″, 1976. Joseph Rotman Collection, Toronto, Canada*

The Chateau in Lowell, Massachusetts, is a late 30s attempt to "streamline" an already existing Worcester diner. This piece of information came to me from Dick Gutman, whose dog Willie is rounding the corner. The Pullman Diner is a more defined, graceful, and dignified example of these now-classic Worcester diners.

I like the cheeriness of the blue, the beyond-baby-blue. Day-Glo menu capitals. Curtains falling in joy. Diner rhythm. It was all so pretty. Really pretty. And the day came along and sliced it in half—as if Beethoven walked over with a huge brush and painted a shadow.

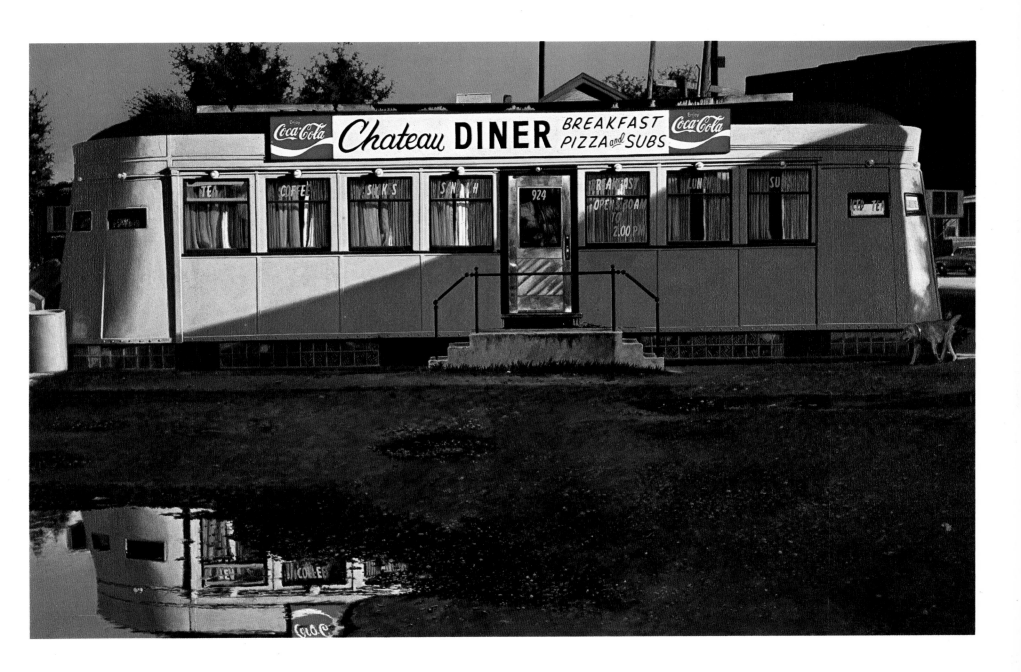

BLISSVILLE DINER, *Watercolor,*
6 3/8 × 8 1/2", 1974. Richard Brown Baker
Collection, New York

Sometimes I can hear a decaying diner say to me,
"Save me, even if it's just a part, but save me.
. . . ." I really and truly feel this—like finding
a lost puppy. That's what happened with the
Blissville, ironically, a name given the diner in
better days. It was rapidly going downhill and
on its last legs, but I squeezed a little life back
into it, and from it, by painting the sign.

DINER—EAT, *Watercolor, 9 × 8 1/4", 1977*
Courtesy Morgan Gallery, Shawnee Mission, Kansas

In the early days, many diners had names painted
all over their fronts and sides. When neon hit
big in the early 20s, it replaced many hand-
lettered signs. It was efficient at night because of
the illumination. It's rare today to find a good
"Eat" or "Diner" or "Lunch" sign. When they
are found together ("Eat" and "Diner" and in
good condition), that's worth five golden stars.
This diner is out on Route 25 in Cutchogue, on
the North Shore of Long Island.
 In addition to collecting toy diners, I also have
started a collection of these diner signs. So far
I have only three, but all of them are gems: an
EAT sign from the Darien Diner in Darien,
Connecticut; a DINER sign from Millerton, New
York (the sign was on a tall pole; there was no
diner); and, best of all, The DINER from
Atlanta, Georgia. All were made in the early 30s,
simple, colorful, and gorgeous relics.

CASEY'S, *Watercolor, 11 × 17″, 1974*
Mr. and Mrs. J. Litvak Collection, New York

*"Casey's" is in Natick, Massachusetts. It's a very
early (around 1924) and very intact ten-stool
diner. Joe Casey specializes in hot dogs, and,
with no exaggeration, they are the best in all of
New England. He has a take-out window on the
right side, and people arrive in hordes. Casey's
is quality not charm—quality.*

*I liked what surrounded Casey's architecturally.
All the buildings are protectors. (Nevertheless,
Casey's has since been moved down the street and
around the corner.)*

*Dick Gutman, ardent fan and neighbor of
Casey's, took me there to sample the hot dogs and
say hello to Joe, even though we didn't know him.
We sat across from him while he was throwing
hot dogs to all the customers. It was human
automation. On the drive over I mentioned to
Dick my fantasy about his response to the
painting I wanted to show him: I knew Casey
was going to react by saying, ". . .that's all
right. . . ." In between servings I caught him and
showed the transparency of the watercolor. I told
Casey I loved his diner and had wanted to honor
it by doing a watercolor. He pulled his glasses
over his eyes, held up the transparency, and said,
"That's all right. What are you going to do with
it? Keep it as a souvenir?" I told him it was more
than a souvenir, and I wanted to say more but
there were additional orders for those scrumptious
hot dogs and he turned around and started to
slide them into their soft buns. We walked out
looking at the early pictures of Casey's near the
door; they were as fulfilling as the hot dogs.*

SILVER TOP DINER, *Oil on canvas, 30 × 48", 1974. Marilyn and Ivan Karp Collection, New York*

The following is a scenario featuring two diner partners. (These are not the true partners nor do they resemble in any way anybody connected with the Silver Top Diner.) They are sitting in the back booth; used coffee cups, cigarettes, wrinkled napkins, and a few invoicelike papers are on the table.

JIMMY: (in slight Greek accent)
"*Hey, Chris, what we gonna name our diner? . . .*"
CHRIS: "*I dunno . . . ahhh. . . .* (slight silence, he sips coffee, inhales) *Maybe, C-J's. You know—Chris and Jimmy's. . . .*"
JIMMY: "*No work. No good.*"
CHRIS: (chuckles, looks around, and points outside)
"*Outside so beautiful. We call it, 'The Fluted-Blue-Glass-Bricked-Beautiful-Diner.' "*
JIMMY: "*C'mon, Chris, not so funny. Be serious.*"
CHRIS: "*I like the silver roof, goes good with the blue, gives us some class, you know, Jimmy. It's nice. . . .*"
JIMMY: "*That's it, Chris.* (excited) *We'll call it the Silver Top!*"

A silver lining. Chris and Jimmy anointed their roof with silver. Fine protection, a silver lining. Roof as symbol. They crowned themselves with that fresh coat of paint, and with their sign, and their new name.

Providence, Rhode Island, historically the home of the first lunch wagon (embryo of the diner), is home of the Silver Top. In Milwaukee, there was the Port Silver Diner. It, too, had a painted silver roof, and porthole windows on either side of the middle entrance.

Speaking of naming diners, the same day I visited the Silver Top I was in Cranston, Rhode Island, a nearby community. The Miami Diner had a huge sign with palm trees and a smiling orange. In Philadelphia there was the Grove Diner, with signage that carried neon palm trees. I theorize that not only people's aspirations but expectations (retirement?) come through in diner-naming and the designing of their signs.

I had a fantasy as this was being written: I'd like to go to all the towns in the country where diners exist and speak to the older people and collect diner names and diner lore. The book will be called, There's a Diner Down the Road.

"VAL'N TINY'S" HAS INCREDIBLE DESERTS – AND A SWEET SHOP. A PLACE FOR PASSIONATE DINER LOVERS.

LISI'S PITTSFIELD DINER, *Oil on canvas,* 30 × 48", 1974
Stephen and Lynn Casner Collection, New York

A great many diners carried flower boxes, and, along with the diners' multistriped canvas awnings, those added a hominess to the symmetrical, railroad-car look. Today when I find a diner with even a hint of a flower box, it's usually in a state of decay. Most people don't want to bother anymore. When I do find a diner that has some flowers, anywhere, it adds extra points.

Bright, cheery, Lisi's.

Most all diner signs are painted by hand, unless they are the plastic-lettered variety. A hand-painted cola sign like PEPSI *is unusual.*

These signs are usually supplied by a local bottler. I have a feeling those PEPSI *signs originally were red* COKE *"circles." The style of the lettering matches the Pepsi lettering. I wonder what happened: did Lisi get a better deal on Pepsi?*

About twenty feet from the diner is a Shell gas station. In the office is a picture of Lisi's in its original state, butted next to the Shell station. It was taken in 1932, I guess about the time both came along. Forty-one years later they're still friends and neighbors. I took a picture of the picture.

BLUE SKY DINER
Watercolor, 9 7/8 × 14 1/4, 1975
Collection of the artist

BLUE SKY DINER
Oil on canvas, 42 × 66″, 1975
Mr. and Mrs. Duane Hanson Collection, Davie, Florida

My neighbor at the time, Bill Medsker, told me about the Blue Sky Diner. I was surprised never to have run into it (considering all the time I spent scouring Long Island City), but it never popped up.

I went out on Sunday to meet the "Blue Sky." It was a rare day in New York City, a clear blue sky that stayed such until sunset. Did the sky know how I felt about a diner's essence? I wonder. Perhaps if it had been a gray, cloudy day the contradiction also would have worked. Who knows? But I like the blue sky with the Blue Sky—it was a spiritual combination.

The shadow was talking: ". . . the sky shall not be clear for long. . . ."

Some diners act as independent pieces of sculpture. They move as you move. I was compelled to do another version of the diner in an entirely different gesture and mood.

Walking around the diner I was wondering about the notion of Father Sky and Mother Earth. I find sacredness in diners. An important rite in early religions was the marriage of Earth and Sky. The diner is the Mother symbol—the great provider.

I dug up something that may be appropriate, a translation of the words Aeschylus puts into the mouth of Aphrodite:

Lo, there is hunger in the Holy Sky
To pierce the body of Earth, and Earth too
Hungers to meet his arms. So falls the rain
From Heaven that is her lover, making moist
The bosom of Earth; and she brings forth to
man
The flocks he feeds, the corn that is life.

92

"JUKEBOX DINER" WOULD BE TOO OBVIOUS, AND SO WOULD "DISCO-DINER". "JIVES" WAS A CONTENDER. THANKS TO THE WURLITZERS FOR THEIR DESIGN HELP.

EMPIRE DINER, *Oil on canvas, 38 × 48″, 1976*
Sydney and Frances Lewis Collection, Richmond, Virginia

I always passed the "Empire" during the day and knew it was out of place. Just like the 10th Avenue Diner down the street four blocks. At night, the Empire becomes stately, changes garb, and turns into a nocturnal melody for Gotham's chic, pseudo-chic, kinky, and pseudo-kinky crowd. A real diner it ain't.

Its stylized Empire-State-Building-Statue-Sculpture adds dimension, but it is flashy and not needed. The Empire—a Redone-Diner-à la Lower-West-Side-Chic; just what you'd expect when a bright group of restaurateurs gets hold of a diner and capitalizes on the past. Too bad

nostalgia is "in": overdramatizing the once-sacred EAT sign (which should be changed to SPEND); candles, reminding me of a Pop-Tarot-Palmist-Astrologer-Reader-Spiritualist, at every table. Feeble attempts to Art Decoize nonexisting Art Deco. Strain. Get the crowds in, boys. Charm. Gaiety. Wine guzzled like slurps of iced tea. All-night mania. Beef Bourguignon: reincarnated beefburger.

Sure, fellows, bring back diners. Bring back all you can, and keep the diner what it was: which is—what it is.

94

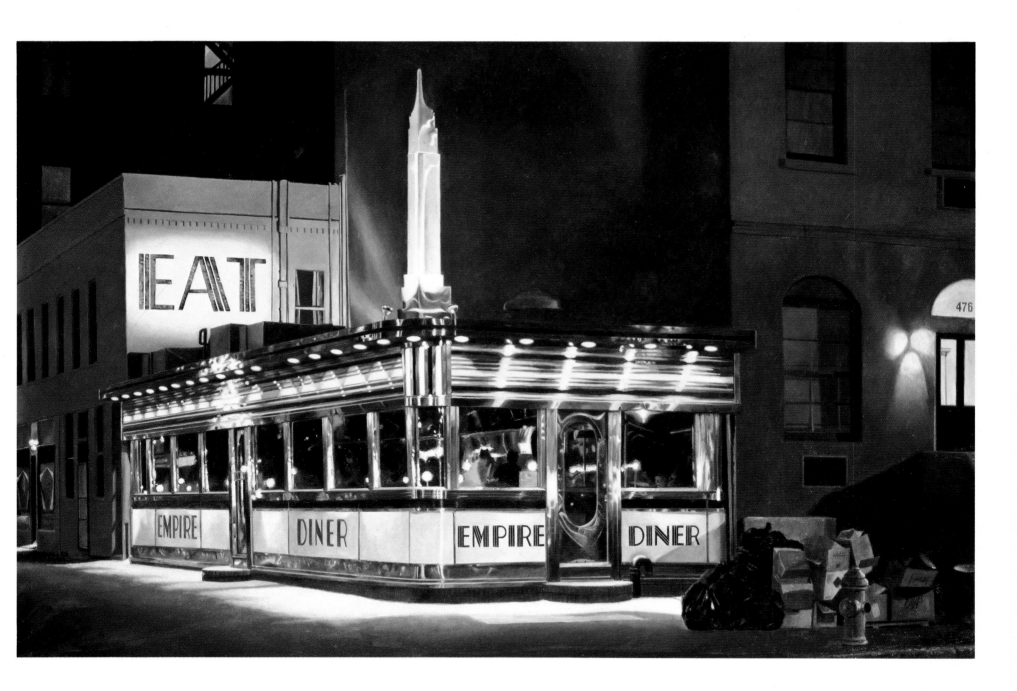

DUTCH DINER

Acrylic on canvas, 42 × 66", 1971
Daniel Fillipacci Collection, Paris

Dutch Diner *was my first painting, the start of a series of postcard paintings of motels, restaurants, gas stations, diners, and small-town street scenes.*

It's significant that I chose a diner to be my first painting, but at the time I wasn't too wrapped up in diners; postcard images were more important to me than the singular diner. They were the images I saw as paintings, and I had to get them out of my system, an important stage in my development.

DUTCH DINER LOCATED AT SHARTLESVILLE, PA. ON FAMOUS RT. 22. MEALS LIKE MOTHER MAKES

Atlanta was a large city, and I had been used to the life there. It was in no way suburban, but then I had moved to the largest city in the country. New York is vertical and gray. Light and dark. Mass and volume. It's a tense and emotional city, always on the edge. After a while there, I realized that the cards represented a vicarious return to the smaller city; it's interesting to note that the majority of the cards were accumulated while I was living in a small town in Connecticut but commuting to New York every day—hardly the best of both worlds. The small city and its life were portrayed in the cards (. . . those small towns I passed on the train. South Bend. Auburn). Horizontal. Easy. Clean. Green. The cards were a link between the two environments.

There was something else going on in those images. America had a sense of caring for itself, and the postcards reflected that value. The Depression was a gigantic wound that went unhealed for many years. The country was surrounded by a dark cloud, and the "modern" movement was an esthetic that helped us keep our sanity and balance. Postcard pictures evoked this milestone of our culture. The war came along as a political solution, and a few years of horrors went by, and the unnecessary bomb exploded. The war was terminated, but so was a giant segment of America's character. Things changed, and the bomb, or the big scare, helped create the hurry-up culture we know today.

The postcard is a definite reflection of our culture, communicating our lives and styles via little pictures. Reading the backside of postcards gives another glimpse of our character. A true American art form, even though its birth was in Germany.

(Other true everyday American art forms that should take a place next to the postcard are jazz, movies, hamburgers, Coca-Cola, and lesser items such as double-knit, the carriage lamp, and eagles above doors. However, there is one American art form that's disappearing rapidly, and that's the diner.)

My intrigue with the postcard grew. You might say I became obsessed. As more cards came rolling in, more information was digested; the fire was blazing. During this period I started questioning: Why? What was this attraction? This pull? This force which I later realized was preparing me for a rebirth I wasn't expecting? I reflected again on the images of driving the back roads of Alabama and Georgia during and after my college years. My sensibilities *were* there then, but untapped. There was no mentor to bring them up or out. Postcards became my mentor. I was constantly amazed by their directness; they said what they were. No pretenses whatsoever; just like those gas stations and general stores nesting on their red clay. There was an integrity that I wasn't too familiar with. An honesty; like the diner, it says *exactly* what it is.

There was a reason for all this.

I started to inspect the cards at closer range. The use of the photo-

graph to transmit and diffuse information became a separate study.

The pictures on the majority of these postcards were taken by the town photographer, and if a town didn't have a photographer, one from an adjoining town would handle the job. Or a traveling photographer would shoot a "scene." These were the guys who took all the local portraits, and snapped the merchants standing proudly in front of their establishments, covered parades, took news shots, recorded accidents, and the rest. Now, this kind of photographer wasn't trained to compose; he knew his craft and practiced it well, but he wasn't an "artist." He aimed his camera, and snapped the shutter, and developed the prints. That's all. And so the subject came directly to the viewer without the photographer's interference. This type of street photographer has influenced me more than any other "artist." These photographers were our visual pioneers because they were instrumental in helping the mass public look at areas of life, and each other. The postcard played a vital role in transmitting this information. In that sense, these people *were* artists.

Most of these postcards were purely photographic in nature; however, as interest and use grew the cards had to be mass produced and mass distributed. The photograph was early transformed into color by mechanical means, not modern four-color process reproduction. This transformation procedure began to enlarge my visual palette. I was on another course.

First, the original photograph was retouched at the printers by another untrained "artist" to give the image more glamour. Telephone wires, shadows, obscure people, and buildings were removed. Images were isolated, to set them apart. Clouds and sunsets (a sign or trademark of postcards of the early twenties through late fifties) and foliage were added. There was no distinct light source; no sense of time. The cards took on a haunting, mystical-surreal quality. By gosh, they were erotic.

Many of these cards were printed on a "linen" finish paper. (Today one can get "silk" finish photographs.) Since the picture was so removed from reality, the idea of a linen finish would somehow make up for the poor picture quality. However, it was the poor picture quality that I loved. Colors were laid separately on a part of the image. They were masked, to speak in printers' jargon. Transparent colors were overprinted in other areas to give the effect of another color. "Dimension." All of this was done over the retouched, halftone photograph. Instant surreal paintings in miniature, not just "postcard reproductions." To the avid and serious postcard collector and historian, these cards belong to the bottom of the barrel. (Nevertheless, today they are expensive, outrageously expensive.) They were known as "throwaways" to many dealers because of their lack of detail.

Examining this transformation process became serious business. I spent many hours with the engraver's magnifying glass studying the buried information in these images. It was like a visual archeological dig. What fun traveling all over an area of nineteen and a quarter square inches. I wasn't an ant; I was out of myself.

SCHANAKER'S STREAMLINE DINER
Elmira, N.Y., Air Conditioned

SCHANAKER'S DINER
Wellsboro, Pa. Pennsylvania's Finest

SCHANAKER'S DINERS
Acrylic on canvas, 42 × 66″, 1972
Collection of the artist

This was my sixth painting and second diner postcard image, but I was still very green when it came to painting and exposure to diners. However, the thrust of my newfound career was upon me. I had to keep cleansing my confidence. The contrast of the diners was exciting. I departed from the original card in painting the upper diner silver instead of pale yellow and in adding a white border. The afterthought of the 1934 DeSoto Airflow was a message to myself: basically it was a communication of my passionate involvement with the Chrysler and DeSoto Airflows (1934-37). I wanted to include one in a painting of a "streamlined" diner, but also I wanted to set up a "form-contradiction." The double image let me do it. This was chiefly naiveté at the time, and it didn't work as well as the Hudson Terraplane in the Houtz Hi-Way Drug painting.

I would also inspect the detail of the purely photographic cards. These were equally exciting because they were the starting point. Each card became a little piece of history, but it was much different from looking at the normal 8-by-10-inch photograph that was *supposed* to have significance just because of its size. The smaller scale focused everything down into a visual abyss. I wanted to bring everything up, like bringing unconscious feelings up to consciousness and growing from them. (A similar process, except this was visual rather than emotional.) I was curious to see how these images would hold up in an enlarged format.

I decided to paint them. My first thought (I was so excited that I was far ahead of myself) was to do a painting of the postcard and then photographically reduce the painting back down to a postcard. I saw this as completing a cycle rather than a visual pun. The idea turned into a complex joke: a postcard that was a painting of a postcard instead of a postcard of a painting. Silliness.

My first painting was of a diner, the Dutch Diner. I had to make my choice for the first painting in what was to be the postcard series. I guess the diners were near and dear then, even though I wasn't too familiar with them. I had a hard time being honest with myself—communicating with *me*. I built a stretcher (a crude one at that), but I didn't stretch canvas on it for a while. I was afraid, and yet I believed. I was afraid to see what would happen. Fear of success? Fear of failure?

The *Dutch Diner* took several months to complete. It was like taking the first jump. The next painting was a gas station, *Stream-Lined Service*. The painting after that was another gas station: *Earl and Lee's ESSO Station*. Then came the *Rain-Bow-Inn* tourist camp. I took the paintings to art dealer Ivan Karp, and he made arrangements for a showing. I quit my lucrative job in advertising and said good-bye to twelve years' experience in art-direction and hello to a new life of painting. I believed in something bigger and better: myself. The rebirth was on, and I entered the unknown.

On to more postcard paintings. On to bringing the postcard back to life. I would mesh myself with the photographer, the retoucher, and the printing press. I became part of the whole. *Kozy-Kabin Kamp, Salad Bowl Restaurant, Octo-Cabins, Melody Tire Co. "Don't Cuss—Phone Us," Schanaker's Diners.* All the collecting, all the investigating, all the digesting. It all came upstairs, and I began to act out and work out an old fantasy: to paint. And to believe. And to know.

In retrospect I've never felt those postcard paintings were too successful. I didn't work out all the problems, which involved an amount of technical knowledge I didn't yet have. It was a fresh, anxious, and green period. The largest ingredient missing was experience. And it sure did show. I knew that but couldn't let it get in my way. I kept on. The ideas were there, and I had to let them grow; it was like feeding the seed and growing with it.

I grew away from the flat, stylized postcard paintings. The photo-

cards were beginning to intrigue me. I enjoyed the "color" in the mono-chromatic photos, the subtle shifts in gradation, the large areas and contrasting smaller areas. The music in painting was beginning to open up to me through these images. The decision to do a grisaille painting was easy because I knew I needed to grow. *Street Scene in Klamath, Cal.* was the first of the black-and-white or sepia series. I started getting into detail, something I was never involved with before. It just happened, and it was more fun getting "into" the painting. It wasn't that I distrusted color; it was an encounter I had to explore, an extension of the postcard concept. Perhaps there is another reason for this "gray" period. I was also going through some intense emotional changes (aside from not knowing where painting would take me), and since gray is a sad "color" perhaps my melancholy was transformed into monochromatic paintings. I don't want to dwell on the psychoanalytic implications; I think that can be ruinous. Intellectually I wanted to push the postcard idea further, and this was the only means to do so.

Postcards still kept coming in, but I didn't go after them with such fury. I let them come to me; I was too busy painting. I wanted bigger and bolder images. Large-format images, meaning 8 by 10 inches, were joining my archive of roadside wonders. I changed my usual canvas to an 8 by 10 proportion, and produced several black-and-white or sepia paintings.

In the meantime I was going out every weekend taking photographs.

Mostly of diners. I persisted in my folly and newfound passion for diners. Collecting diner pictures replaced collecting postcards. When I received cards, I'd just throw them in the drawer. With pictures of diners, I studied them at great length: the same digesting and sorting as with the postcards.

The pictures were just documents of diners; they weren't thought out as paintings. I was loving diners more, but I wasn't obsessed with the idea, as with the postcards, of building up a stockpile. More pictures—more sorting, kneading, feeling, touching. I knew I was about to take another plunge, and I also knew I needed to practice painting. Maybe the grisaille paintings were the exercises.

I always took pictures in color and in black-and-white. There was a haunting theme in most of them, and this goes back to the photos I shot way before starting to paint. There was a sense of isolation and symmetry. This goes back to the cars I used to line up under my bed (the garage) when I was about four years old. The images I'd see looking out the train window. The old cars I'd feverishly look for with my Baby Brownie. The lonely gas stations on the back roads coming home from school. The images on all those postcards. My personal photographs of storefronts, and buildings, and people isolated in their environment. The lonely diner. For me, painting starts with the urge to share and the wish to communicate. Since I don't sing, or tell stories, I fulfill the need to let others participate in another way. It has to do with giving to the outside

GRAND CANYON TRADING POST
Oil on canvas, 28 × 40″, 1972. Collection of the artist

The photographer had an assignment, and if the light wasn't good it didn't matter. No "art for art's sake" for him. He didn't know from plastic elements. I like that attitude; it's primitive. Raw. Honest.

I've always liked flat light. Still light. The stillness of the early-evening beach. There's a similarity in the light stillness. Grand Canyon Trading Post has that quality of light: nonlight-light.

This is another of the cards that was a "scene." Upon investigating it with a magnifying glass, I put myself into the scene. It dates from around 1950–51. Who were those people? Where are they today? Is the trading-post-cafe-gas-station still around? Where were the people coming from? Where were they going? Where was I when the picture was taken?

During the painting I was reliving the experience of the people, and the cars, and the photographer who shot the picture, and the totem pole, gas pumps, steps. The person who sent the card. The person who sent the card to me. All the other people who handled the card. All the people who experienced the Grand Canyon Trading Post. And on and on and on. . . .

Grand Canyon Trading Post - On Highway to the Grand Canyon - near Williams, Arizona

world, which in turn gives to me. It's a way of overcoming isolation—the insular activity of painting is enough for one to bear.

In a sense I am a representational landscape painter and not a "photo-realist." I paint the landscape, or part of it, and I represent an image that impresses me. Impression and Expression. Very simple.

We live in a label-oriented society. We are so label-conscious it's obnoxious; however, that's a fact of life and a piece of "realism" itself. It's called merchandising. I am labeled a "photo-realist" because I use the photograph to do a realistic-looking painting. It looks photographic, but only so because of preconditioning and merchandising. It is not photographic; it is pure painting. Jazz is a label for a style of music, but it's *just* music. (The label "Jazz" does admittedly sound better.) "Photo-realism" is just painting—representational painting and not "ism" painting.

I use a 35 mm color slide. A print is made which functions as a device for me to acquire information for transformation. The photo is not the subject for my paintings. (It used to be.) The diner is the subject, for the moment.

When I first started to paint in Atlanta I went to those "summer-art-school-with-the-wealthy-matrons-who-love-to-paint-still-lifes" classes. We went out on "field trips" and set up our easels, brought out the paint (they all used alizarin crimson; I couldn't understand it, only Renoir could use alizarin properly), and got nothing done except to drink beer and chitchat. I moved on to be by myself. Even then I was so conscious of being out-of-doors that nothing got painted. That is, nothing got painted well, and that's where all the difference was. I wanted then to take pictures, go home, and paint them. In my head I knew this was okay. In my heart I thought it would be cheating. There was no encouragement, and I didn't have the confidence to pursue all my feelings.

The camera is an extension of my eyes, of myself. It is not a separate instrument to make lovely photographs; that's too easy anyhow. Besides, there are a few *great* photographers, and an overabundance of picture-makers. The pictures I take are visual notes, thoughts, feelings. My gosh, the camera has been used in painting for over 150 years. The absolute greats used the camera, camera devices, and the photograph. I will slight many artists, but a few who used the camera seriously and recognized it as an important force in their painting are Delacroix, Ingres, Courbet, Church, Cézanne, Eakins, Degas, Picasso, Rouault; the list is endless.

The early photographs and the paintings that come from them are all frontal in composition. I'd compulsively get in the middle of the door, or walk straight out from the diner's center, turn around, and confront. That was always the first step. Then I'd walk around to the side, and the

rear. Shoot angles and close-ups. Like meeting a person. Confront directly first, then go around him. Like the immediate handshake; you'll learn a lot about that person in the first few moments. It was pure for me; I was directing myself toward the diner and the diner was directing itself toward me.

I am moved by diners; it cannot be explained. It is absurd to ask an artist what he means by his product. I have different meanings at different days and hours and at different stages. It's true: if you're an opera lover and love the melody, you'll get more out of the opera if you know the story.

There is a certain spiritual lift to be gained by having been touched by deeper material things. I don't mean this in the high, religious sense. The artist has a role, similar to that of a scholar. It consists of grasping truths so often repeated to him or her. Now, these truths take on new meanings, and the artist (or poet, writer, musician, person) makes them his own (I'll repeat—his own) when he seizes their deeper significance.

Diners "talk" to me for a number of reasons. After all, we love objects (human and nonhuman) for conscious and unconscious reasons. These conscious and unconscious truths are communicated back and forth, as in conversation. The diner, as subject and object, becomes human, and breathes, and expands beyond the boundary of its natural appearance.

HOUTZ HI-WAY DRUG
Acrylic on canvas, 42 × 66″, 1972
Marvin and Sheila Friedman Collection,
Miami, Florida

Sepia browns and reds on old photos and postcards are lush; the color variations are so rich. I did several sepia paintings to work out this coloration with paint, but also to work out some images that had to be put down.

The first sepia painting was Houtz. It was a postcard that I was fond of. It was "art-director-graphic." After I completed the painting, I studied it and felt there was something missing —it was a sense of passing through the city and coming across "Houtz." As a personal statement I added the car I may have been driving at the time—as if I pulled over in excitement and impolitely parked the wrong way. (I do this at diners under the stress of excitement.)

The typed-style "title" was actually on the card. It was a method not so often used on postcards of that period, but I liked the idea and wanted to carry it all the way through.

Houtz Hi-Way Drug
Limon, Colo.

STREET SCENE IN KLAMATH, CAL. ON REDWOOD HIGHWAY

STREET SCENE IN KLAMATH, CAL.
Acrylic on canvas, 42 × 66″, 1972
Mr. and Mrs. J. Maze Collection, New York

This was a and the pivotal painting for me; not because it was a black-and-white photo postcard painting, but it was the first painting where I started getting into detail. I was beginning to paint representation (re-presenting the image), and I enjoyed the monochromatic paint: modeling and shaping. I was beginning to feel the process of painting for the first time.

HOLT'S CAFE, *Oil on canvas, 42 × 66″, 1973*
Charles A. Carroll Collection, New York

"Holt's" is another postcard I always loved looking at and studied carefully. The painting talks for itself. Those kids have something important to say. The cop is listening attentively. He was in a hurry since he left his car door open. The bus driver is in the middle of the conversation. Now, that old man, he just walks the town looking for idle conversation. He'll go home and keep the entire family posted on the day's happenings.

The buses lined up (. . . the cars lined up under my bed when I was a child). I love early buses, especially Greyhound in the days when they had no fenders (or just hints of fenders) and streamlined fenders were painted on the sides to portray speed and motion and grace. The lamp pole, so out of character, yet it's a spatial breaker (postcard-plasticity); tensions for composition.

Most of the postcards of this period (late 30s, note the Plymouth) were titled by lettering in black ink on the negative. There were many styles from many parts of the country; however, the common style was the italicized uppercase letterform. I'm sure it's because the titles were easier to read, more "scrapbook" oriented. I wanted to follow through with that in the painting.

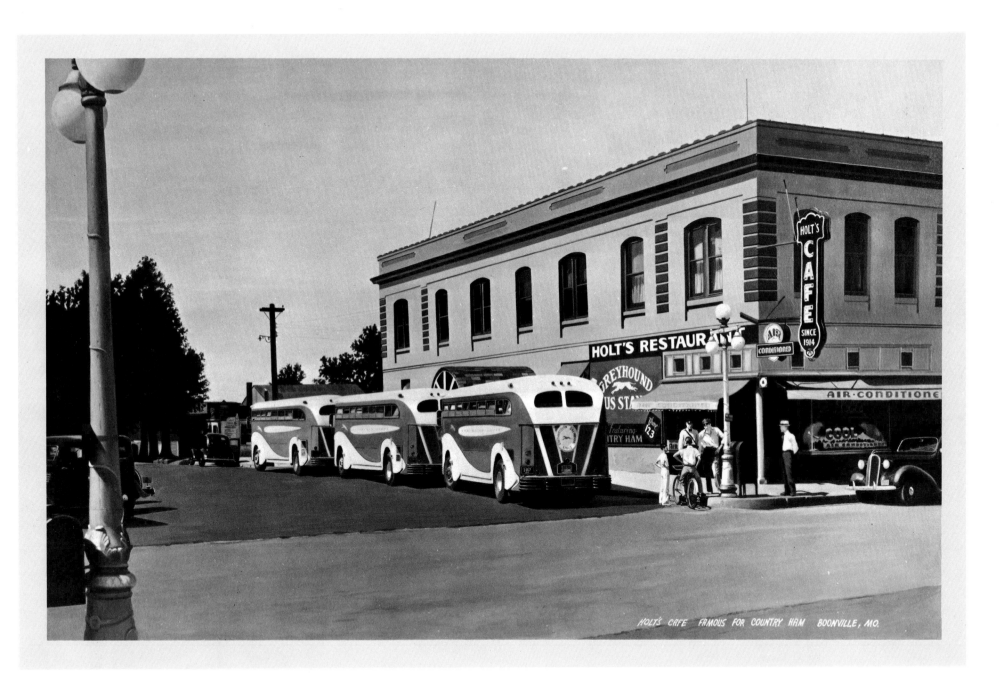

HOLT'S CAFE FAMOUS FOR COUNTRY HAM BOONVILLE, MO.

MIDWEST CAFE, *Oil on canvas, 60 × 72″, 1973*
Mr. and Mrs. Edward Elson Collection,
Atlanta, Georgia

*I closely identify with the photographers who
worked for the Farm Security Administration.
Perhaps that's why so many of my paintings have
a "documentary" look rather than a "painterly"
look (here again the ever-present fascination with
the street photographer).*

*The Library of Congress has on file every
picture taken by the dozen or so photographers
involved with the FSA during the mid 30s to
early 40s. I spent two days going through all the
photos, which constitute the most effective
photodocument of America ever produced. I
admired Russell Lee most. I had a few of his
prints copied and went home for careful study. I
found that I not only identified with the photo-
graphs but with the era and the struggle and
pathos America was going through. (I wonder if
I was also identifying on a psychological plane,
exposing some of the broken pieces in myself.)*

*I called Russell Lee and asked him if he'd mind
if I did a painting from a few of his images. He
was honored, he said, and so was I. The paintings
paid homage to him and to all the images he
photographed. Russell Lee was a Midwesterner
from Ottawa, Illinois, and he grew up in the
small-town atmosphere. He even tried his hand
at painting for a few years.*

HIGHWAY DINER, *Oil on canvas, 42 × 66″, 1973*
Richard Brown Baker Collection, New York

*When Dick Gutman and I first met several years
ago, we exchanged much diner talk—and also
pictures and other paraphernalia related to diners
and the great American roadside. He had a photo
of this diner. I couldn't bear seeing it so small
and knew it had to be painted. It was a way of
preserving the picture rather than the diner.*

While I continued to do monochromatic paintings in oil, I also wanted to see what I could get from watercolor. I wasn't too familiar with the medium, so I wanted to work in monochrome first, as a warm-up, and to be consistent with the present imagery.

During this period I met Steve Izenour and Paul Hirshorn from the architectural firm of Venturi and Rauch in Philadelphia. Steve and Paul had written an interesting article in an architectural publication about White Towers. We met, exchanged ideas, and they supplied me with many black-and-white photos of White Towers. I used these photos to do paintings. Coincidentally, the White Tower in Camden was an inspiration for all of us. I used to pass it all the time on trips to Philadelphia and say to myself that I must paint it someday. It was my very first painting, even before the postcard diner. Steve and Paul were so inspired by this particular building that they decided to take photos of all the White Towers in the area, which prompted them to do research documenting the history of White Towers, which led to the article and, now, a book.

WHITE TOWER, CHICAGO, ILLINOIS, *16 × 13″*, *1974. Private collection*

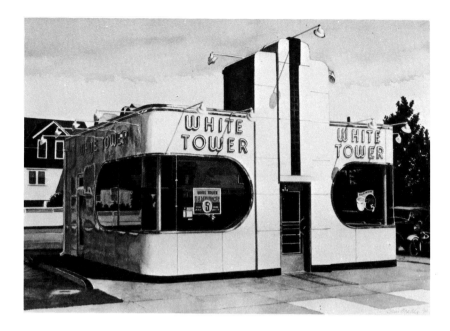

WHITE TOWER, COLLINGSWOOD,
NEW JERSEY
*10 × 14 1/4″, 1974. Mr. and Mrs. John Hoffman
Collection, Kansas City, Missouri*

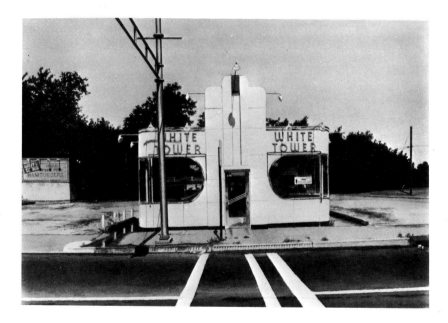

WHITE TOWER, CAMDEN, NEW JERSEY
*8 × 12″, 1974. Mr. and Mrs. William Jaeger
Collection, New York*

WHITE TOWER, PHILADELPHIA, PENNSYL-
VANIA
*12 × 15″, 1974. Larry and Cindy Meeker
Collection, Kansas City, Missouri*

WHITEY'S DINER, *Watercolor, 12 × 17″, 1977*
Courtesy O.K. Harris Gallery, New York

When Dale R. Potts was seven years old, a friend of his renamed him "Whitey." The name has stuck for sixty-five years. Whitey says he was a towhead as a child and that his hair always has been white, as was his mother's. Whitey calls himself a sandwichman, or a counterman, or a short-order man, and has been at his craft for fifty-three years. He started out at Spot's Diner in Sidney, Ohio, to work his way through college.

Whitey has been at his present location since 1954. He's mighty proud of his double griddle of the same vintage. He likes to show you where the original trolley wires were hooked up in his diner, even though you'd never know it was a trolley diner that's been around since the late 20s. Route 18–20 that runs through Fremont, Ohio, was the old track on which the interurbans carried Fremont townspeople to Toledo and back.

Whitey had three immaculate spatulas face-down on fresh, folded towels in front of those '54 Hotpoint grills, and they brought to mind the counterman in the Majestic when I was five years old. At the same time Whitey pulls out a Camel (Is he that same man reincarnated?) and I tell him the story about the spatulas pressing down on the burgers; Whitey says, "Yeah, I still do that . . ." and he tokes on his Camel. And I tell him about those white hats and how countermen used to wear them, and Whitey says, "Well . . . I don't wear 'em, but I've got 'em down here. Want to see 'em? . . ." It was a perfect visit.

I told Whitey my views on the idea of using white as an outside color, about the White Castles and White Towers, and the whole idea of cleanliness and good food. And I asked him if he felt his name and image were an advantage in his success. He agreed they were.

An old friend sent me a picture of an antique trolley-car diner, the Sandwich Cafe in Findlay, Ohio. It was well appreciated and hung around as a reminder for a while. A couple of years later my sister, who lives in Cleveland, sent me more pictures of the rare relic. These were tighter shots, and I got a better glimpse of the diner. These pics also hung around for a while. Then they began to haunt me. I wanted to paint that diner, but I would have to go to Findlay first. Time passes on.

I started to think about the missing link in diner history. Not one lunch wagon remains (except in fantasy), yet there are many diners from the early twenties around, and some in mint condition. But what about the trolleys? I figured it would be worth the gamble to head toward Cleveland; the Sandwich Cafe might provide clues.

The quest was on. I called the Chamber of Commerce of Findlay to get some scoop. The diner had been removed, but I wasn't disgruntled. I located the new owner, Ed Galitza, who was a preservationist. Ed's pretty serious about his business; in the past eighteen years he's preserved an entire town, building by building. He calls it GHOSTTOWN, and it's about five miles south of Findlay. Ed is planning to restore the diner inside and out. God bless him.

In the meantime I located the son of the original owner. We had lengthy conversations about the diner. His father purchased several interurban trolleys in the late twenties and made diners out of three of them. The Sandwich Cafe was the last survivor. It closed its doors sometime in 1955. I guess it was the town landmark for nearly twenty-one years. On its site there had been an opera house, but when the talkies came around it was torn down. And then I talked with the last cook, who had been there for the final eight years. Well, he had foggy memories of the place. I asked him what the specialty of the house was. "Hamburgers."

It didn't upset me that I had arrived in Findlay a year too late; somehow I knew something would happen. It was a matter of deduction. I learned that many of the smaller towns around the Toledo area were fed by the interurbans, and I figured that if Findlay had one others would have them. I psyched myself out for diners and trolley-car diners.

Bowling Green, Ohio, was the next town up the road. Ed told me there was a diner there, but not a trolley. That suited me fine. I drove into Bowling Green, and it was a smaller Findlay. It was like driving into one of my postcards. The town hadn't changed much in forty years. Take a left at the main light, down Main Street, and there it was, a really old diner with partially new ribbed-metal siding. It was all white, no color trim. The interior was vivid Landlord Green. It was Sunday, as always, and the diner was closed. A youthful gas jockey told me that three

"little ol' ladies run the place . . . they only serve lunches and they stuff you; I mean they only stuff you." I asked how old it was, and he said it was pretty old, "at least twenty years, 'cause I'm twenty-one." The diner had to be at least fifty years old. I was with Linda, my thirteen-year-old niece, who had never seen a real diner before. She was so excited that she begged me to return so we could eat there the following day.

The next diner "attack" happened down the street in Bowling Green. Now this place was pure diner inside, impure outside. It was the more homey variety. It had a sweetness about it; I mean, I could tell the people who ran the place were real nice folks who loved their work, and loved making their customers happy.

On to Fremont, Ohio, and Whitey's Diner, a deceptive little place that resembles an old house; it has three gables. Whitey was closed; he only serves breakfast and lunch, but he welcomed me with warmth and friendship. In fact, above the kitchen is a glaring blue neon sign that says "Welcome" in friendly script. Whitey said he wants everyone to feel welcome, not only in the diner, but in the kitchen too.

Whitey's is immaculate. Spotless. He had closed for the day and there wasn't a morsel of food around. Not even a drop of coffee in either of the two urns. He took me through the kitchen and storage area and even the garbage room, which he also took pride in because it was so clean and odor-free.

I took pictures freely, chatted about matters other than diners: politics, Midwest politics. There were two pictures of Eisenhower on the wall, one of MacArthur. (Whitey had been a good friend of Robert Taft.) Whitey gave me his menu and an ashtray from the Motel Ding. He knew what I was about; he knew I liked to have relics from diners I visit. And I knew what Whitey was about. We "touched" each other.

There were once four trolley diners in Fremont, and Whitey's was the last one left. If you look up over the counter, you can see the trolley trappings. That's all. Otherwise it looks like any homemade diner.

On to Cleveland, and I am already high on diners. We are passing through Monroeville, Ohio, and it is dark; on the left I see a faint row of windows; I slow down and refocus; yes, it's another diner. We get out of the car, and time freezes. Margot, Linda, and I step back fifty years. It's a sixty-foot interurban trolley. Untouched since the day it left the tracks, which were just a few feet away. The owner was closing (he starts serving at 5 A.M.), but he invited us in. I couldn't stand it, I was in diner heaven. I knew right away that the owner was a private, eccentric character. I had to be delicate. I invited myself back to his kitchen, and he quickly shoved me out. He was polite about it, and finally warmed up to us all—guess he needed company. I was asking for some early pictures, but it wouldn't have made any difference—the diner hadn't changed since 1926, except now it's without a striped awning. He became very nice but after looking through seventeen identical cigar boxes he

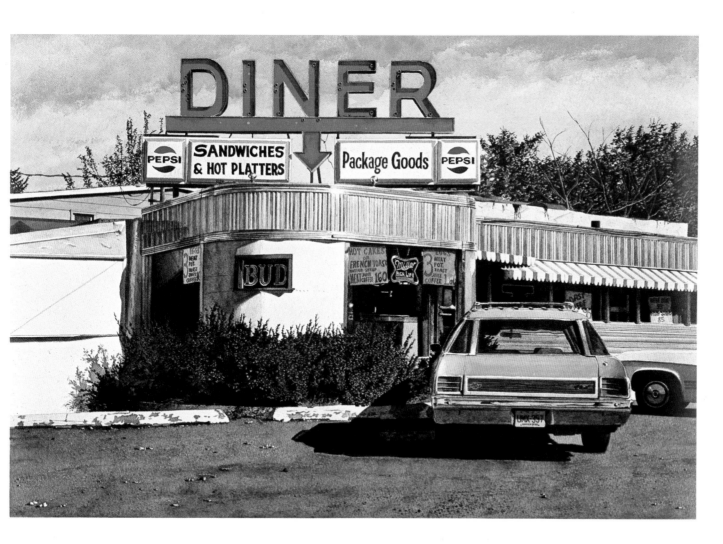

JAMIE'S DINER
Watercolor, 13 × 20″, 1975
Mr. and Mrs. Myron Ginsburg Collection,
New York

*I pulled into Jamie's after revisiting the
Royal one day. It didn't strike me as too cool
a diner. (The next day it could have been a
hot one.) I was looking for another point of
view. There was a flurry of activity in the
rear of the diner (visually, that is). I wasn't
satisfied, so I pulled out of the lot to head
onward. One more final look through the
right-side window of the car; it clicked!*

 *There was a different framing: the
greeting of the curve and the large diner
sign. There was a boldness I didn't see
before. The frame of the window
refocused it. The gesture of the Chevrolet
wagon, turning its back to me ("don't take
my picture"); Jamie's out front. The
interrelationships set up an ambiguity, and
the light seemed to have reversed the image,
like looking at it in a mirror.*

 *I get involved with the paintings, and I
sometimes want to return to the diner to see
any changes. I went back to Jamie's. It had
disappeared.*

couldn't find the picture he knew he had. I told him that I'd return in a few days to take pictures of the diner, and not to worry about it. The first thing I do when I go into an old diner is to ask for pictures. I'm so damn curious.

Decorating the diner is an array of dime-store animal vases loaded with plastic flowers. More plastic flowers; it's like a mini-carnival of plastic flowers, all faded with age. They're all over the place, it looks like they grew out of all the cracks. The diner has a ten-stool counter, several booths to and fro. Jukebox. Refrigerator. Two TV sets. Stacks and stacks of newspapers. On the wall above the counter is a plastic chef that's a light-switch plate. That made it for me. I asked the owner where he got it.

"Hardware store, where d' y' think?"

I was diner-high the rest of the way to Cleveland. What a find! I went out after the Sandwich Cafe, but wasn't disappointed that it was gone; look what happened! Diners come to me; I don't go after them. We pass through Wellington, Ohio, and there's another one—not a trolley, but a sweet diner. Also white. (The fifth-straight white diner of the day.) What made this diner (Al's) so nice was its location: right in front of a railroad depot complete with Pullman-type cars. Marvelous juxtaposition, and one of my dreams come true. On to Cleveland—flying.

I return to the Monroeville Diner after learning from a guy who runs a hot dog–cotton candy trailer in Clarksville, Ohio, that the owner's name is Frank, which he wouldn't divulge the night before, so I hadn't pressed him. After taking rolls of film of the exterior I go inside, and Frank finally finds the original Polaroid. It's in a Lucite frame, the kind usually picked up in Miami Beach. It's postcard size, and the picture slips into the Lucite; glued outside the frame is some plastic green "shrubbery." Inside the frame is a motel postcard; the Polaroid of the diner is in front of the postcard, but a piece of the card image shows through. It looks like a collage I would do for fun.

I snapped a few pics alongside a sugar container and napkin dispenser at the counter, having opened some curtains to get more light. After I was through with this set-up I casually pulled my camera up and started taking pictures of the colorful interior, whereupon Frank threw his apron at me and told me to get out of the diner; he said I was invading his privacy and I couldn't take pictures of his home. I apologized profusely and told him I meant no harm; I didn't think the outside was any different from the inside. He didn't agree. We fought continually, but finally came to terms after about twenty minutes of verbal diplomacy. I had made one mistake, and that was not to ask permission to photograph the interior. I always make this gesture, but we were so friendly the night before, and he'd been so helpful trying to locate the photograph. . . . Who can say what happened. Frank knew my purpose, my quest, my passion for diners, but I triggered the wrong emotion and that made him angry. I entered his diner, his home, and was not made welcome.

I knew all along a diner that wonderful was too good to be true.

"TIME TO EAT GOOD FOOD"
Watercolor, 8 1/4 × 12″, 1977
Courtesy Morgan Gallery, Shawnee Mission,
Kansas

There are many diners hanging around that have been closed for years. They usually hide out in small towns. They occupy their respective sites and sit aging, as if they were rocking away on a porch. Their owners, retired, keep the diners for sentimental purposes. And I can't blame them. The diners are their homes (. . . the cars in the yards with the frame of grass).

Some of these diners remind me of old photos buried in the bottom drawer, in a shoebox, with a fading red rubber band holding the bulge that isn't there. This clock is from such a diner. The diner was too sad to paint; I felt I would be invading its privacy. It's in Saugerties, New York, on the main street, a few blocks from town. It had an EAT sign which, to me, was a sacred piece of art. The clock shared equal billing. The idea of "Time to eat good food" touches me. A simple statement, words meshed with the instrument for time-telling became story-telling. Time had stopped. No more eating. No more good food. No more gala petunias in the flower boxes. A frozen diner in Saugerties.

WINGED CLOCK, *Watercolor, 8 × 15″, 1977*
Collection of the artist

The people who build Fodero diners are responsible for this handsome clock. I wish it were on my wall.

From the time Lindbergh hit the dirt in Paris, the winged motif appeared everywhere in American design. (And European design, too.) Flight, birds, sky, clouds, and the new spirit in aviation in general played a dramatic and profound role in the reshaping and rethinking of our new design-oriented culture.

Yes, time flies.

Starship Diner

TICK TOCK, *Watercolor, 10 3/4 × 13 3/4", 1977. Mark Johnson Collection, Kansas City, Missouri*

Today the "Tick Tock" is a giant stone-surfaced diner resembling a fortress. It was an old, shimmering Silk City Diner (manufactured in Paterson, New Jersey, the "Silk City"); the Musi Dining Car Co., makers of the new diner, came and hauled it off to their "graveyard." I was on hand at Musi to get a glimpse of the final touches and to inspect the resting place of Tick Tock number one.

I talked with Katherine Ramoundos before the Tick Tock came down. She was sad and patted the Tick Tock like it was a dying old dog and told me how she and her husband Nick worked so hard to send their two sons through college.

My curiosity was killing me. I had to ask about the "Eat Heavy" sign and what it meant—as if I didn't know. We strolled inside, and Katherine pulled out an 8 × 10 black-and-white photo of a tattooed trucker sitting at the counter with a huge portion of food. She said her husband designed the sign and wanted to tell everybody that the food is good and the portions are big and that no one should leave the Tick Tock hungry. Eat Heavy.

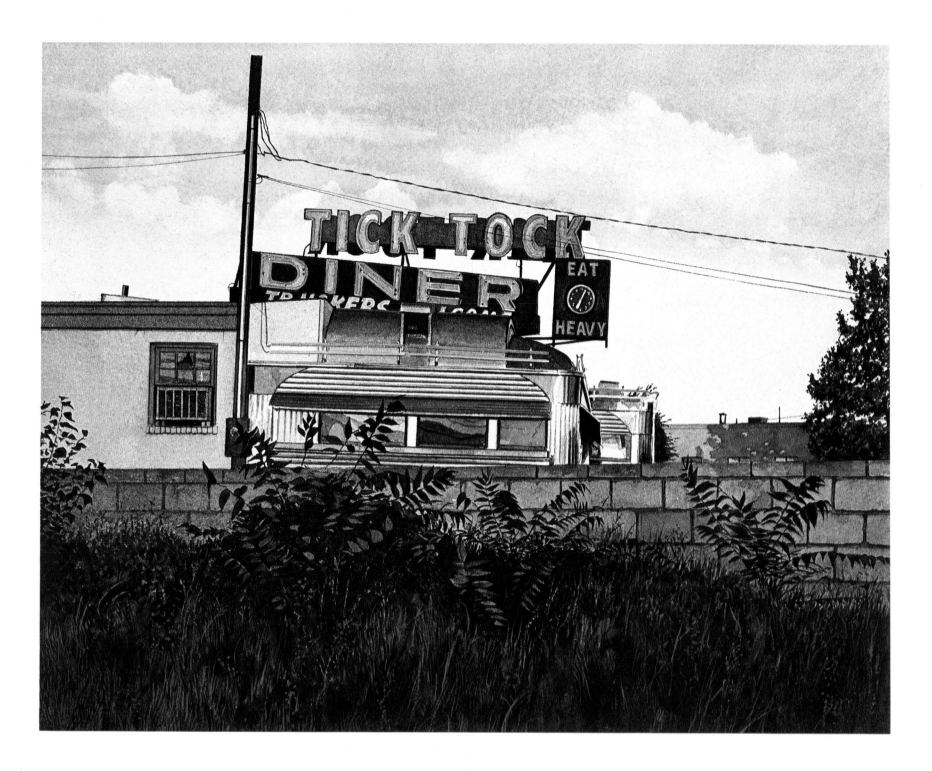

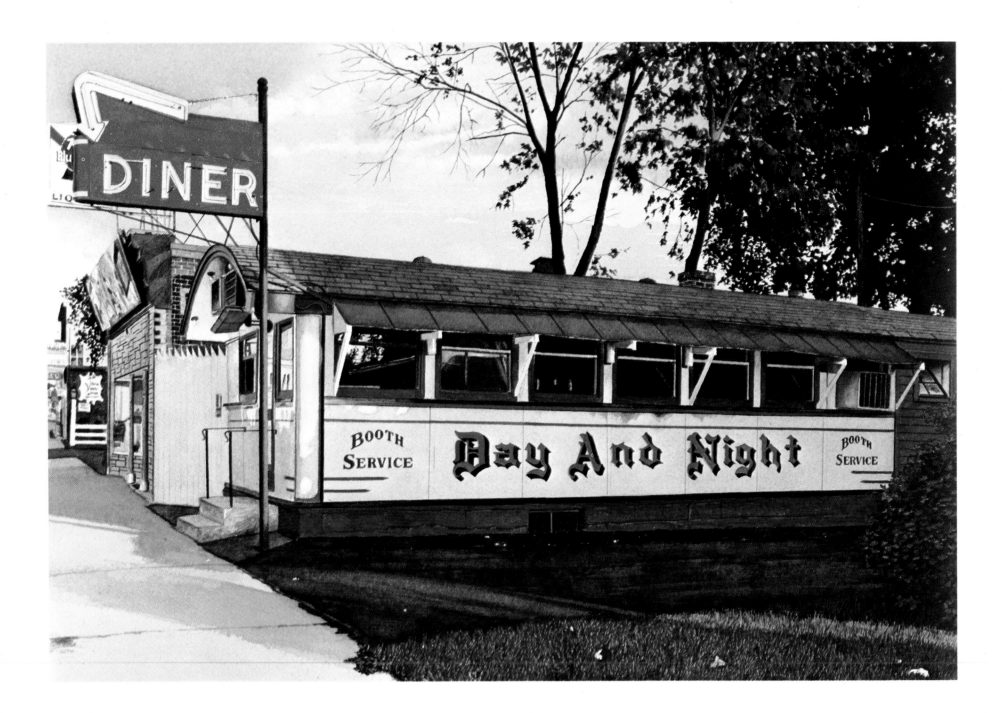

DAY AND NIGHT, *Watercolor, 10 5/8 × 13 3/4", 1977*
David L. Stewart Collection, Kansas City, Missouri

I was in the middle of the street taking pics of the "Day and Night," and a police car cruised by. We checked each other out by not checking each other out (ultimate cool). At the time I was bushy-bearded. Palmer, Massachusetts, is a sweet and small provincial town. I can understand that there was bewilderment on the officer's part.

I drove off and was waved over to the side by the town cop, who was kibitzing with a local. Before he uttered a word, I thanked him for stopping me and told him what I was doing. (The first step in badge removal.) I told him I was doing my job, and that I was glad he was doing his. I wasn't being smart; that's cop psychology. Without his asking, I handed over my driver's license. (Second step in badge removal—the .38 disappears.) I told him I was doing research in his fine town and that I did paintings of diners. I knew it might sound strange to him, but everyone to his own kick. He's a cop. I'm an artist.

He couldn't understand it. I had some transparencies of paintings with me and pulled them out. By this time his police identity almost slips away, but he has to do his job and so gets on the squawkbox attached to his shiny black belt. Static. Inaudible voice from HQ: "He does what?"

". . . does paintings of diners."

"After all these years, I've heard 'em all."

"Yeah, that's why he was in the middle of the street. He takes pictures of diners."

"He paints diners? You mean like art stuff? . . . Well, everybody to their own kick."

I was accepted. We started to talk, and I showed the cop more pictures of paintings. He was getting into the diners and the paintings. He understood. He pointed to a diner down the street and said I shouldn't miss it. Told me also where there was a diner on the road a few miles out of town.

I drove off, inspected the other diner (not so hot), turned around, and waved good-bye to the cop and his friend. I could hear their conversation.

(I now knew what the Lone Ranger felt like when he galloped off into the dust to hit another episode.)

"Who was that masked man?"

"Why, don't you know?"

"No."

"Why . . . why, he was the Lone Diner Painter."

MATCHBOOK
Watercolor, 3 1/2 × 8″, 1977
Collection of the artist

Advertising specialty houses would offer blank
matchbooks, which the individual diner could
order with its name imprinted in allotted spaces.

O'CONNORS DINER
Oil on canvas, 42 × 66″, 1976
Robert B. Hodes Collection, New York

It was a long hot day driving, and I was tired;
my edges were dry and worn, and numb. In fact,
another diner wouldn't have made any difference;
I didn't want the involvement. I needed a physical
and visual rest. It was on a late July afternoon
entering Woonsocket, Rhode Island, rounding a
curve, and there stood new heat—"O'Connors,"
its redness glaring at my fatigue. We stared at
each other. Suddenly it was as if a bulb went on
in both of us. Red on Red. I pulled into a parking
lot, casually removed sticky self from sticky seat,
and started examining. Front. Three-quarter
front. Side. Full. Close. Milk-bottle white. Red
again. Bricks. Pinch of green. Lush tree. Blue
sky. Cloud wisp.
 Red meditation. O'Connors rekindled my
spirit, and I came alive and offered my thanks for
the new awakening. As I drove off, I thought of
Matisse, and Hans Hofmann, and Barney
Newman. And I wanted to share this redness
with them. They would understand.

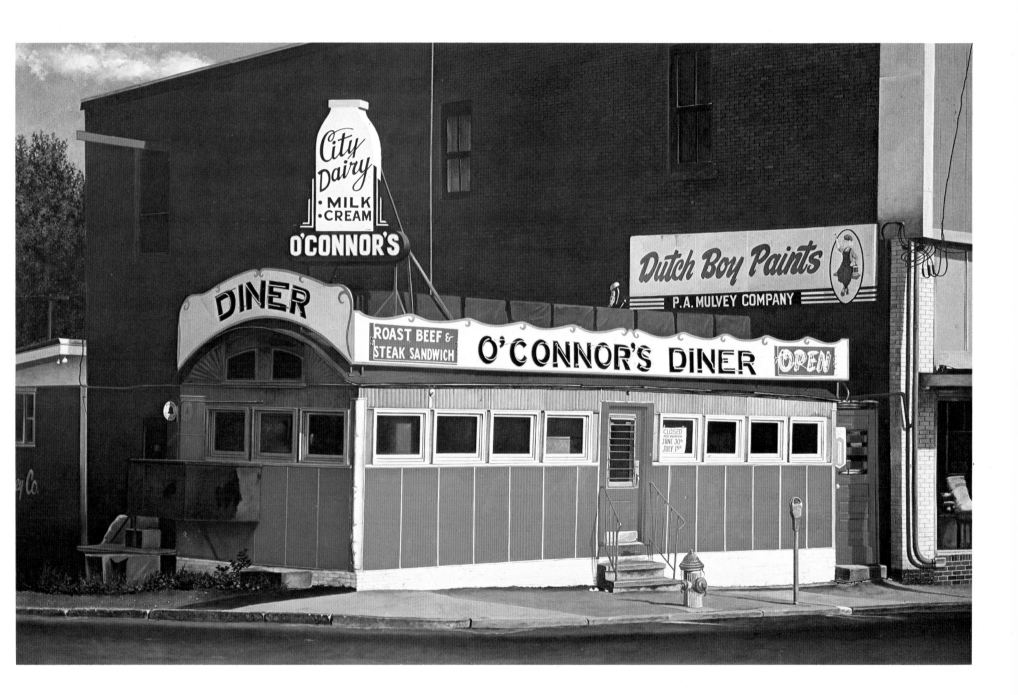

COFFEE CUP
Watercolor, 5 3/8 × 7 1/8", 1977. Private collection

*A widely used diner symbol is the coffee cup. It's
the expression of unity, warmth, friendship, and
hospitality. (That may change as this is being
written, with coffee prices skyrocketing by the
minute.) Nothing is sacred anymore; as the
diner passes into our cultural past, so does the
cup of coffee.*

*This cup was part of a marvelous array of
baked enamel illustrations on the outside of the
Green Diner in Bedford, Massachusetts. Judging
from its design, it looks as though Miró was
around to give a few suggestions.*

WHITE CASTLE
Oil on canvas, 30 × 40", 1976
*Dr. Marvin Klein Collection, Southfield,
Michigan*

*I have days when everything I see is a painting.
And everything I see could be a painting. Many
places on the road—other than diners—are
paintings for me. Frustration. I'll be on the
subway trying to rationalize the torture and ease
the anxiety; unable to read because of the noise
and crowds, I start gazing at all the colors,
textures, and folds and shadows. Instant
paintings.*

*Routes 1 and 9 is a frequently traveled road,
and I have painted a few diners on this strip,
and want to paint more. I always pass the White
Castle in Elizabeth, New Jersey, and wonder
when it will fall victim to the maws of the
demolition team. I fear it will be replaced by the
new "Castles" that look as if they were cut out
by giant pinking shears.*

*The greatest joy comes in the "driving-by"
and looking out the car window at a certain
moment and capturing that moment as
composition. I see it as a painting then. Not
everything always fits, and that's part of the
fitting. Attempting to recapture this "fitting" once
removed from the car, on foot, is virtually
impossible. I always wanted to experiment with
this thought and take action, and the* White
Castle *is an example.*

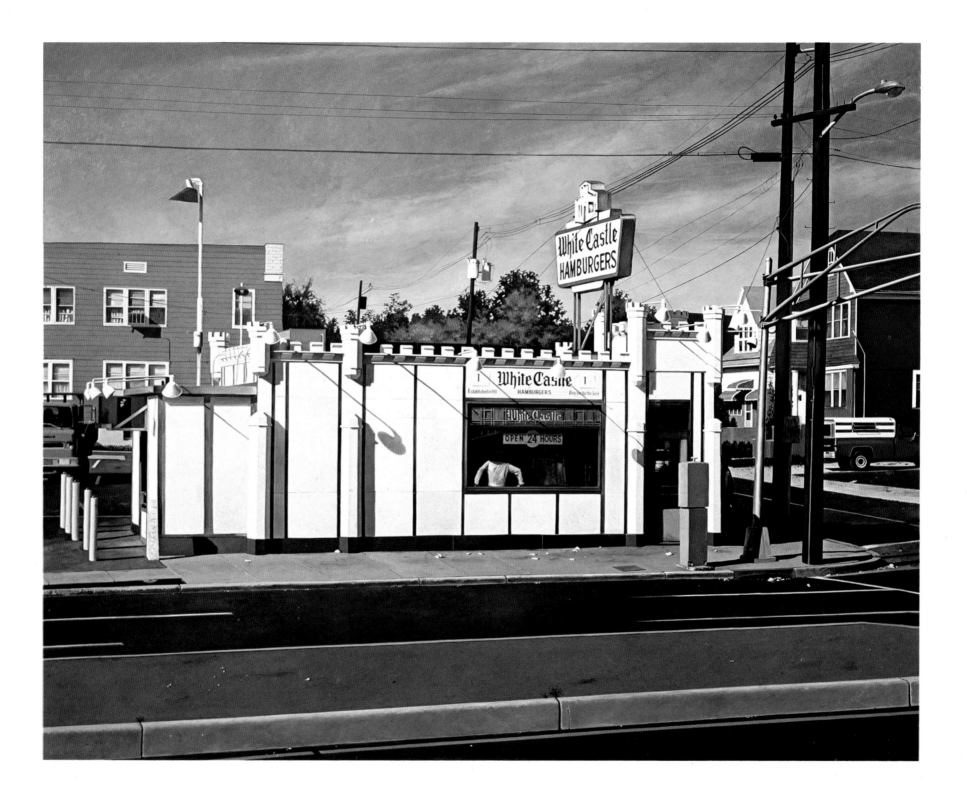

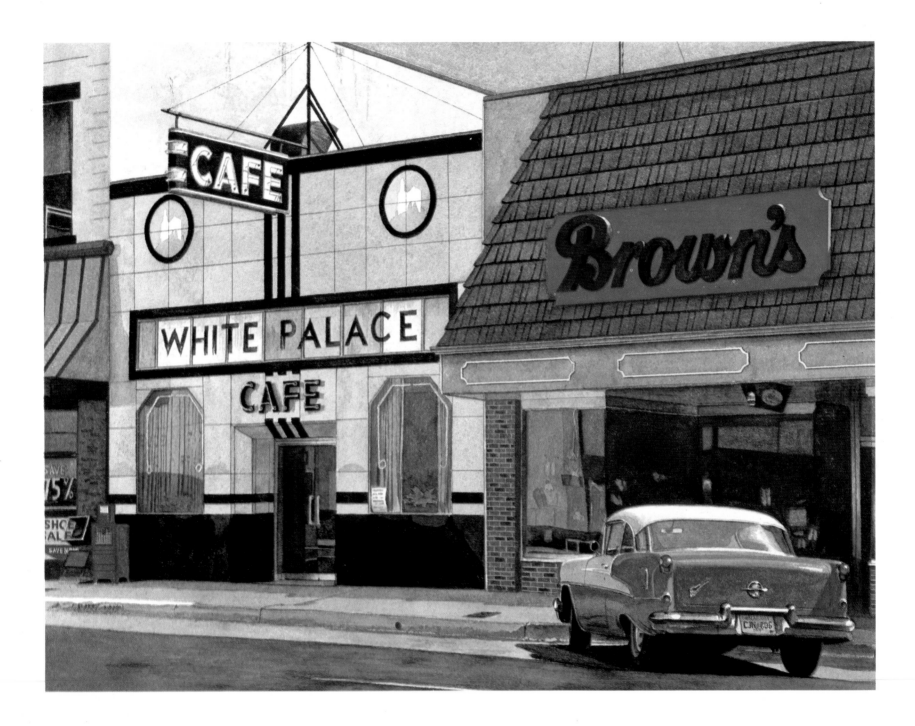

WHITE PALACE, *Watercolor, 12 × 16", 1977. Courtesy O.K. Harris Gallery, New York*

Entering a new town for the first time is a great adventure. I roll in slowly, like the honcho in the cliché Western movies; my head goes from east to west, peripheral vision on full blast, always checking the rear-view mirror for an impatient driver. It's the postcard trip in live action, and three dimensions, and sometimes fourth and fifth dimension, like the moment the White Palace stuck its face out to greet me in Gadsden, Alabama. It looked like a poster for a 30s architectural facade show. I just never know when a hard-core-five-star-heavy-duty piece of the past will confront me.

I believe the White Palace was a reward for a long, long dinerless journey, and all the years of travel. I was driving south from Washington through Virginia, and Tennessee, through Alabama. There were no diners en route, just some awfully good roadside marvels. All I expected was the unexpected, and that's when it's more fun.

Alex Greenwood runs the White Palace. He is the only Greek immigrant I know with an English name. He described the whole story to me, history and all, in getting an English name. That's not important. Alex opened the restaurant in 1938, when the facade went."modern." He said it had been a restaurant since the turn of the century. Alex has a sense of history, and he has good taste, too. He knows how handsome his cafe is. The town of Gadsden, like so many towns in America today, had to go through its face-lifting to keep up with the times. The town "revitalizing" committee was quite upset at him because he was the only one who didn't make the move—like all the other merchants—to redecorate his facade. Business has dropped because of all the other fast-food places that cropped up in recent years. Alex likes it the way it is, or the way it was. He's going to keep it that way.

In a few years he wants to retire, and maybe move to Florida, and he figures . . . why not? He wants to keep the White Palace the way it was, and the way it should be.

ASHTRAY
Watercolor, 7 5/8 × 11″, 1977
Rick Meyerowitz and Marlene Bloom Collection,
New York

SISSON'S, *Watercolor, 9 1/2 × 14″, 1975. Collection of the artist*

*These days discovering a real trolley-car diner
in full operation is a rare experience and a real
treat. Too bad it was Sunday (again) and Sisson's
was observing the sabbath. I'm sure the people
in South Middleboro, Massachusetts, have some
kind words about Sisson's. It had the look of
good grub, and there was total evidence that the
interior wasn't "messed-with" too much in order
to keep the trolley look.*

*In Independence, Missouri, there is the Trolley
Drive-In. First of all, it's not a drive-in but a
drive-up. Like all diners. I figured they were just
playing off the name to be cute, because the place
wasn't a diner or restaurant. It was nondescript,
and when you're hungry in Independence any
place will do.*

*Inside there's a narrow, low counter (diner in
concept), kitchen and grill to the side. We order
our yummy-burgers and coleslaw. Wait and chat.*

*Suspicion sets in as I roll my eyes in 360° roll-
abouts. Flash! it's a trolley car.*

*Why was I fooled? Every original feature was
masked in some way, but a few details sneak out
and shriek—trolley! Desperately I had to talk
with the owner, but he refuses, too busy cutting
onions or something. I persist, and although he
reluctantly appears he's most elusive. I get the
picture: this guy is ashamed he has a trolley car.
They were a throwback from the early years—
the image of greasy food, dampness, and fly-by-
night operators. Okay, understood. But why then
the name: "Trolley Drive-In"?*

*I sincerely conveyed my interest in getting
information about the diner, and the owner just
walked away back to the onions. Well, the
coleslaw was darn good, and I was with a new
friend, and we were having a good time, and that
was nice.*

128

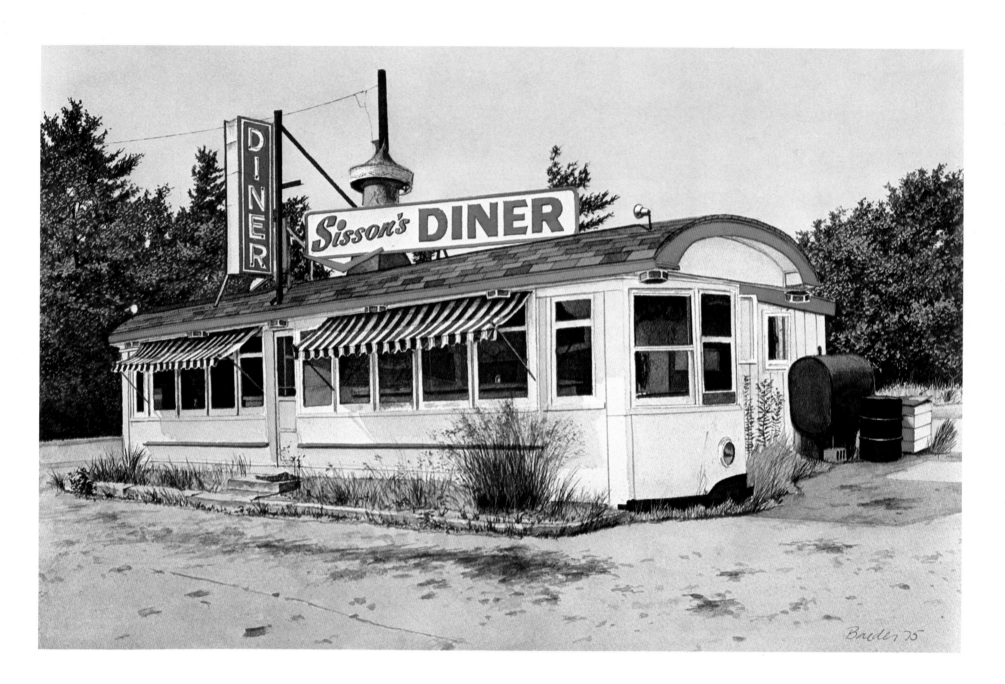

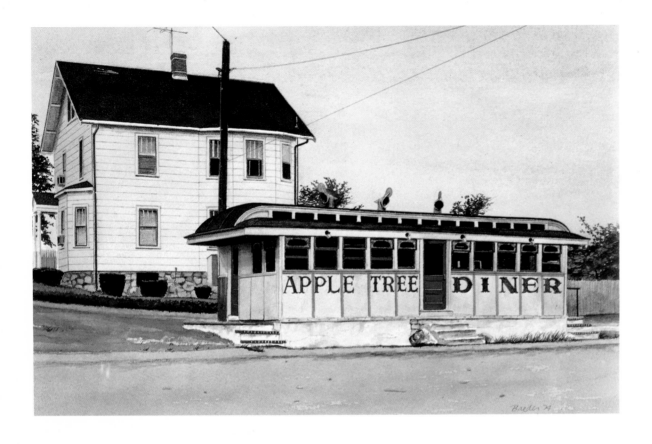

APPLE TREE, *Watercolor, 10 3/4 × 16 3/4", 1974*
Richard Brown Baker Collection, New York

*The passivity of early-morning serenity and the
pastoral quality of the air are cleansing: favorite
subjects of so many poets, writers, and musicians,
and artists. In menu jargon, it reminds me of
"farm fresh." The negative side of the day is easy
to deal with. Peace of mind. As I approached the
Apple Tree, its owner bedecked in nightclothes
approached this bearded stranger with camera
in hand. Two curious people coming together,
solitude broken. Soft morning words were
exchanged, a few clicks to start the day rolling,
and within moments we were on our separate ways.*

EPICURE DINER, *Watercolor, 15 × 22", 1976*
A. Haigh Cundey Collection, Essex Fells, New Jersey

*Diners have gestures, like people. And, as with
people, time solidifies and magnifies the gesture.
Diners sit, stoop, kneel. They have an attitude.
Some stand with grace, even though their dresses
are tattered. Some follow the fads and lose their
character. Some depend on their neighbors.*
 *The Epicure sits secure and well-protected by
the strength and delicacy of its close neighbor.
It's located on the corner of 31st Street and
Hunters Point Avenue in the heart of Long Island
City, New York. Many diners supply eats for this
vast area of warehouses and light industry.
(There's even another "Epicure" in the area, of
similar vintage.) During the week the area bustles
with working people, and trucks, and an energy
that feeds nearby Manhattan, across the
Queensboro Bridge, and the surrounding area
of Queens and Brooklyn. On the weekends, Long
Island City reverses its image and becomes a
haven for bleak and barren images; tiny
communities nestle among the industry. The
Epicure is on its weekend rest (taking a breath
of fresh air) from the demands of all the
appetites that grace its small quarters.*

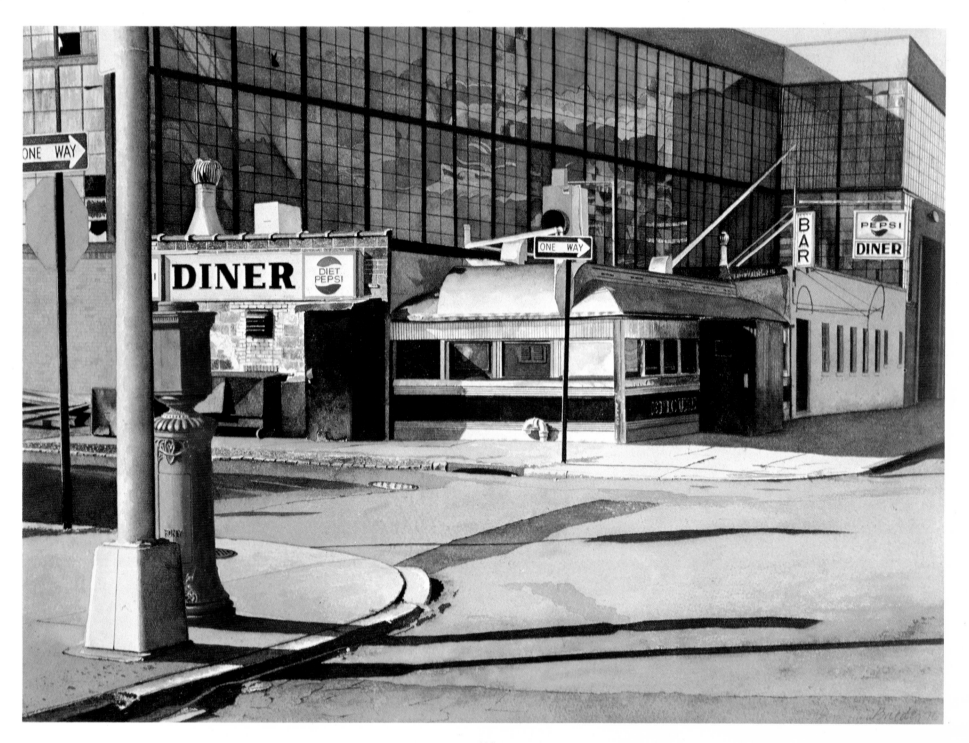

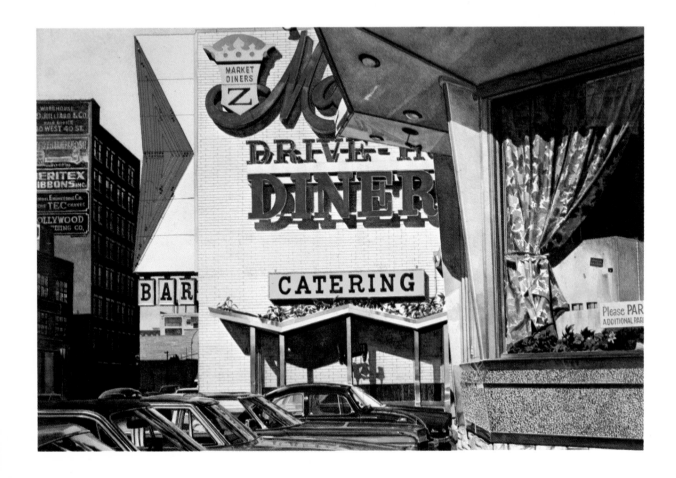

MARKET DINER
Watercolor, 15 × 22″, 1975
Jack Handen Collection, Bound Brook,
New Jersey

Walking around the "Market" as if it were a
sculpture offered a great deal of "abstractness":
the cacophony of texture, shapes, colors, forms,
and all the necessary elements that created the
more pleasant relationship I had with the diner
than with its owners.

MARKET DINER
Oil on canvas, 42 × 72″, 1976
Sydney and Frances Lewis Collection,
Richmond, Virginia

There are several "Market Diners" in the New
York City area. This is the largest and most
famous. One of the bosses didn't like the way I
parked my car one day (where the Yellow Cab
is, next to the Continental). And he didn't like
the idea that I was only having a cup of coffee
at 6 P.M.: high dinner hour, high profit time.
He wanted me to remove the car so a "paying"
customer could have the space. He didn't like me
using the phone since all I was having was a
cup of coffee. I told him my intentions of being
at the diner, and he wanted me to leave.
 New York diner experience. "Get 'em in—get
'em out. Bottom-line is all we care about."
 Zig-Zag. The 60s look in diners. Get the
windows larger. Show more curtain. Get the
people in. High-turnover. The new diner hype.
Gigantic menu with gigantic prices. This is
what's happening to diners in and around the
big city.

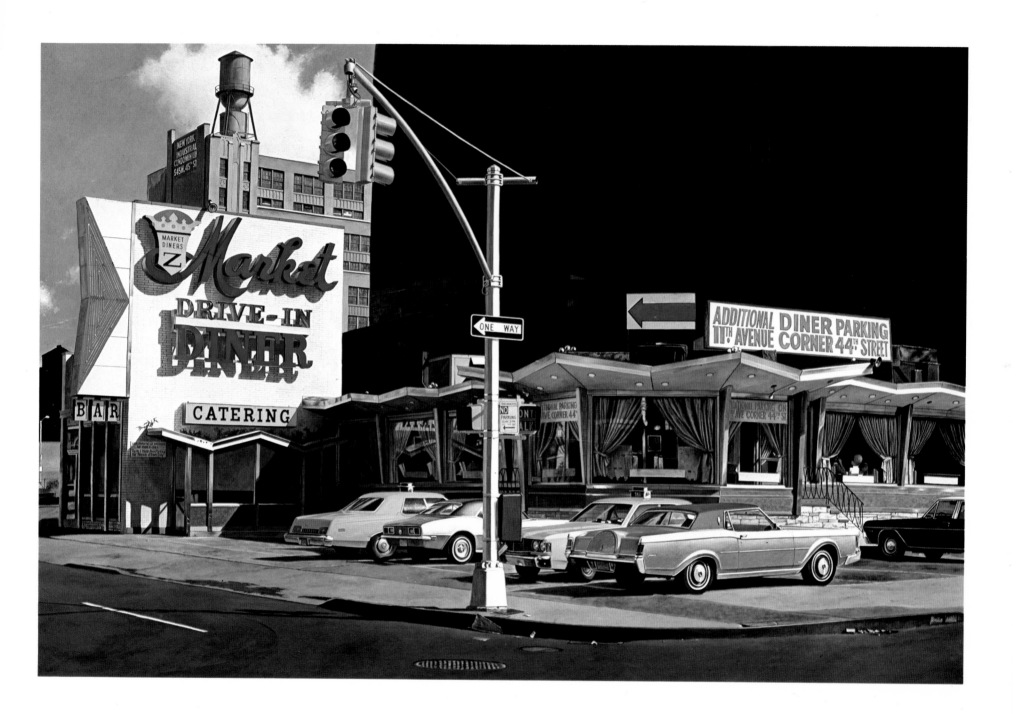

133

DOGGIE DINER
Oil on canvas, 24 × 25", 1975. Private collection

The Doggie Diner is one of a chain of eateries in the Bay Area surrounding San Francisco. The cartoon dog is indigenous to California pop-infested architecture of the 30s and 40s. Conceptually these are not diners but fast-food take-out and eat-in places. In fact, the newer versions are mansardized and even more plastic.

This particular "Doggie" is in Richmond, California.

DINER, *Watercolor, 10 1/4 × 15 1/2", 1976*
Courtesy Morgan Gallery, Shawnee Mission, Kansas

It was a crisp early fall day, and I decided to drive to Binghamton, New York. I stopped off at "Pals" on Route 17 for the usual. "Pals," what a great name for a diner, and what a great way to have gotten a day started. This was a good diner-search day. Pals. Me and my car, buddies on the road.

Empty miles pass; no visuals, nothing, just solid rural country. I get bored. I hope. I keep going out of hope—maybe a little need and greed thrown in. I was beginning to feel like the poet or the scientific inquirer; the delight of discovery was upon me.

And there it was. The sweetest diner I ever saw. Homemade. I don't even remember the name of the town. I was too excited to inquire and couldn't locate it on the map. So what. Too bad it was closed; I couldn't understand why since it was a busy weekday, and I desperately wanted to go inside. I knew it was as Springtime as the outside. I thought about knocking at the house next door; obviously the owners lived there. (Was this diner an extension of their earlier vegetable and fruit stand?) Sometimes I feel as if I intrude. I have respect for the privacy of others. I drove off delicately, feeling good.

THIS WAS THE TEMPLE OF MOUSAKA.
A FEW CENTURIES LATER THE DORIC FAMILY
RESTORED THE STRUCTURE, AND IN CUSTOM CAR
JARGON, THEY "CHOPPED" THE TEMPLE MAKING
IT MORE BEFITTING.

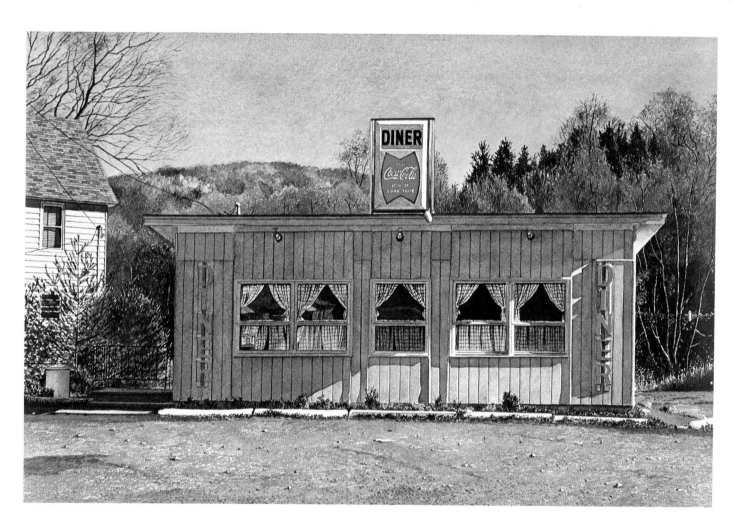

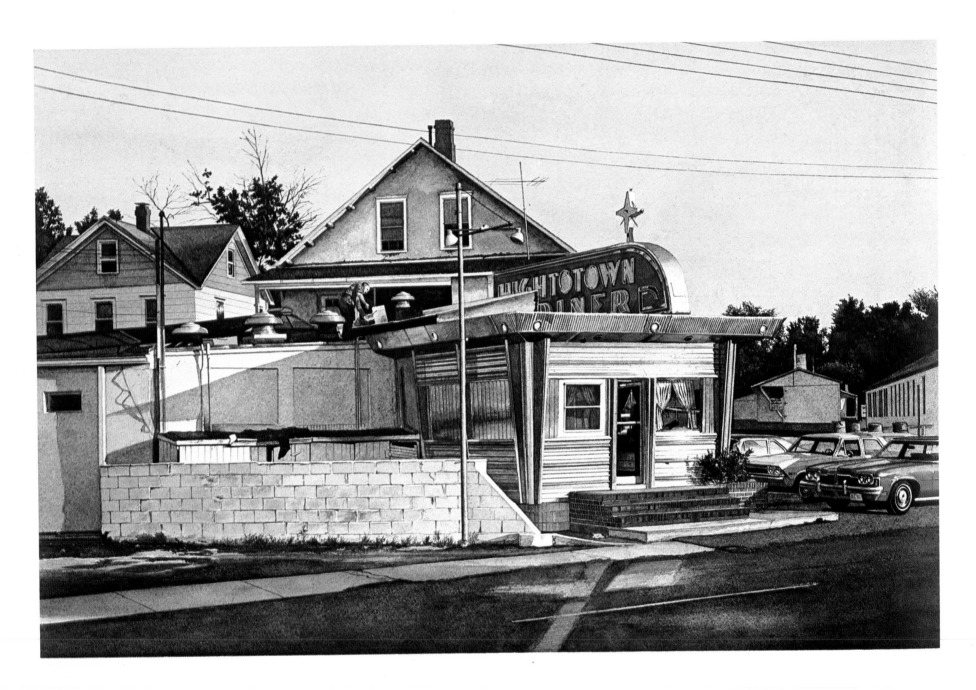

"WING'S" (FORMERLY THE "DRAG-ON-INN") IS CHINESE-AMERICAN. IT IS FACADE ONLY. THE INTERIOR IS PURE DINER - NO ORIENTAL MOTIFS. HOWEVER, ONE OF THEIR SOUP SPECIALTIES IS THEIR HEAVENLY BIRDS NEST SOUP.

HIGHTSTOWN DINER, *Watercolor, 16 × 22", 1976*
Pollock, O'Connor, and Jacobs Collection, Waltham, Massachusetts

I acquired a postcard of the "Hightstown" in its earlier days. The sign was as large as the diner. The typography aroused my attention because I have always had a fetish for 30s goofy commercial letterforms. (Grossly revived today.) Traveling to Pennsylvania one day I passed the diner; the sign was there but the diner had been replaced by a new metal monster. Shame. I was disappointed, and even angry, because I wanted to work out my card fantasy. The contradiction of character disturbed me somewhat, but I understood the owner's motives (dollars not heritage). I got aboard a "semi" and took a picture of the sign since that was a good vantage point. Now I had a picture of an old diner sign to add to my collection of old diner signs. Nothing more.

Time passes and I'm whizzing past the Hightstown again; it's late in the afternoon and I need a coffee fix. I ignore the sign, the diner, the past, the postcard. Had my coffee. As I walked out the sun was saying good-bye for the day, and that in itself got the juices flowing. I walked around the diner, and new things were beginning to happen, especially to the rear of the diner. I got involved with the diner's involvement with its neighbors. They didn't seem too friendly; they were nonaccepting of the diner. And each in his own way put up with each other. I wanted to put that down.

And that man, whatever he was doing on the roof, seemed like a mediator.

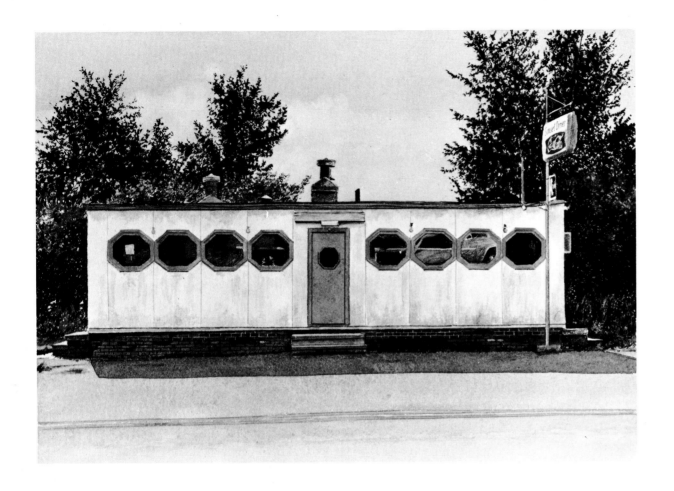

SUNSET DINER
Watercolor, 9 × 14", 1977. Private collection

The "Sunset" affected me because so much could have been done with it. The owner, and probably the builder of this homemade wonder, had an idea but didn't know what to do with it. It was on its last legs, and from the side it looked as if it were ready to collapse—tired and worn.

I was intrigued by the design intent. The octagon windows butted against each other, their ocher trim so unfaithfully painted along with the aging white. I think the diner had a jaundice of some kind. It was as rickety inside as outside, although closed.

The octagon shape, so rampant in the late 30s as a shape (along with the circle), as a "modern" motif, wasn't used successfully. And yet there is still an inviting quality about this diner; it is a piece of folk art.

STEVE'S DINER
Oil on canvas, 30 × 48", 1974
Martin Seligson Collection, London

In my earlier diner-search days I passed Steve's. It was late at night. Cold and black. From across the street, a gas-station lamp shed cryptic rays of light. New Jersey has towns like Nowhere, Overthere, Noteventhere. Steve's was Somewhere.

Magritte poked his head out the door that night and offered a cup of rock. I wasn't in the mood. I thought the BLOB was approaching any moment. (Remember that movie? The Blob overtakes the Downingtown Diner. . . .)

I returned the next day, bright and shiny. Death came alive. I looked down at the cement floor and saw the oiled imprints where all the people had bowed to Steve's.

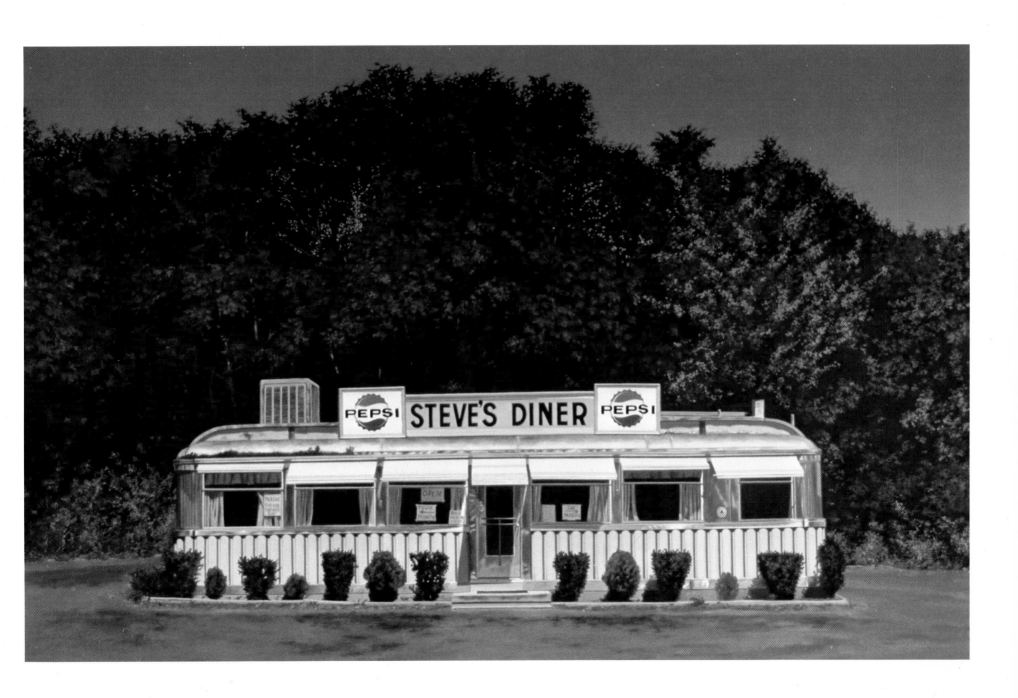

TERHUNE'S PALACE CAFE
Watercolor, 15 × 19″, 1977
Collection of the artist

Dick Gutman and I exchange dinerabilia.
As a historian, he has an extraordinary
archive of early diner photographs. I look
at them as he does, and we both fantasize
"being there." I like to go back in time and
place myself in front of a diner and do an
on-the-spot drawing.

 It is like a historical dream that comes
true.

he history of the diner is far richer than the pleasure one can get from diner food. This, too, is a broad area of expertise. Aside from the fascinating history of diners and their manufacturers, there are countless legends and tales revolving around diners and diner people. This study, however, is reserved for my good friend and faithful colleague Richard J. S. Gutman of Dover, Massachusetts. Nevertheless, I can't be so intoxicated with diners and paint them with such frenzy and not know and tell a little about their history. It's like getting to know the grape and its vineyard if you enjoy fine wines. If you don't do it, you're cheating yourself. I have to thank Richard for aiding me and expanding my historical horizons.

In 1872 a Providence, Rhode Island, man by the name of Walter Scott took a regular horse-drawn freight wagon and outfitted it with some food-serving equipment. Scott set out to town loaded with sandwiches, pies, and coffee. He was an instant hit. (Can't you see Walter's operation today?: plastic wagons, red and yellow, and huge signs reading: 678 Billion Sandwiches Served.)

One of Scott's customers, who had a keen mind for competition, bought a few sandwiches and saw the potential. His name was Sam Jones, and he built a few lunch wagons for himself. Free enterprise on the move. Competition grew, and the lunch-car industry was on its way. Then, a chap by the name of Thomas Buckley of Worcester, Massachusetts, came along. He had a little more style and flair. Buckley recognized that these lunch wagons could use some schmaltz, a quality missing in the earlier wagons. He started building lunch wagons that were more enticing to look at, and to be around. These wagons had chrome fixtures, ceramic tiling, marble counters, mirrors, stained-glass windows with etched figures, and painted scenes on the outside paneling: pure opulence. Buckley knew how to merchandise food with his circus-wagon sensibility. Diner names were embellished with gold filigree, and there was gold leaf scrollwork decorating entire surfaces. All this was an invitation to good, cheap, fast food.

Meanwhile, horse-drawn trolley cars were being discarded for the newer electric versions. People eager to jump on the lunch-wagon bandwagon were buying these trolleys for practically nothing and outfitting them with food-preparation equipment. Architecturally, the trolley design became an important influence on diner manufacturers in the twenties and thirties. The most striking carry-over feature was the monitor roof, which gave diners the railroad-car look.

It was Charlie Gemme (in charge of The Worcester Lunch Car Company for fifty-five years) who was the pioneer in classic diner design.

QUICK LUNCH
Pencil, 7 1/4 × 10 1/4″, 1976
Richard and Kellie Gutman Collection,
Dover, Massachusetts

He saw the similarities between lunch-wagon construction and that of street and railroad cars. Today Charlie Gemme would be called Mr. Diner.

The all-night twenty-four-hour business was a result of the lunch wagons' being forced into finding permanent positions on a street. Lunch wagons did business from dusk until 10 A.M. the next morning, when they were forced off the street by many city ordinances because locals (who should be around today) thought the wagons were eyesores. So, to avoid this situation, operators dismantled their rolling capability after finding a good site, and then they had a permanent location. The twenty-four-hour business was born. There were larger menus and more business. The diner was on its way to becoming an important place to have a quick, solid, wholesome meal.

Automobile production skyrocketed during the twenties, roads expanded, cities grew, and more people were on the move. Diner manufacturing started to gain ground, and the legendary Patrick "Pop" Tierney became an innovator in the dining-car business. He called his lunch cafes "diners," which stemmed from the dining car on the railroad. He built restaurants on wheels. Yes, they were actually built on wheels, with metal construction, and oak paneling, and a wooden roof, and steel body—just like a dining car. They were fitted for electricity and gas. Interior fittings were usually mahogany, while floor and walls were

tiled. Counters were marble. Gas range, refrigerator, and steam table were installed, along with nickeled coffee and water urns. Stools were white porcelain with mahogany or oak backs. Sometimes they were leather fitted with nickel-plated trim. Individual brass footrails accompanied the stools. All the woodwork was varnished. The roof was done in a waterproof duck. The body was any color you might choose, painted in enamel. Ted's Diner is a grand example of a beautiful Tierney car; it was rolled on its wheels from the plant in New Rochelle, New York, to its current home in Milford, Massachusetts.

Tierney was a pioneer in diner manufacturing for another reason: he brought in booths and tables and even toilets. For all of his accomplishments, "Pop" made himself a twofold million. He deserved it.

Another Irish millionaire legend is Jerry O'Mahoney. Jerry would give a customer the most profitable location, service the diner, and on top of that he had a unique deferred-payment financing plan. The owner of the new diner knew then that O'Mahoney had a vested interest; it would be a sure profit-maker because of this personal involvement.

Paramount Diners were innovative in devising a system of splitting the diner lengthwise when it was to be transported; the two halves were shipped separately, then joined together. One half was the counter, booths, and back bar; the other half was the kitchen and storage area.

Most diners were built in the Northeast, with the majority of

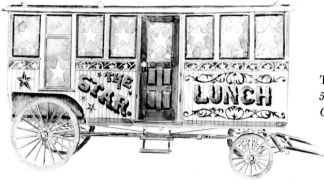

THE STAR
5 × 10″, 1977
Collection of the artist

manufacturers located in New Jersey. The most famous builder in the Midwest was the Valentine Manufacturing Co., in Wichita, Kansas. They made prefabricated sandwich shops and diners in a variety of exteriors. The interior was pretty much the same, with a ten-stool counter and six to eight booths.

The Kullman Dining Car Co., in Avenel, New Jersey, remains the oldest company still operating, and it is now the largest. Kullman was responsible for the new brick, stone, mosaic, beach-pebble, terrazzo-floor style diners: the "Mediterranean-Romanesque" look. I was curious about the design of these diners; who actually worked out the plans and materials? I asked Robbie Kullman, third-generation diner builder: "Who really designs these ugly diners with all the stone and brick and arched windows? I think they're awful." Robbie quietly replied, "Me and my mom."

There were plenty of other diner manufacturers, all unique and all innovative in one way or another, with names like Bixler, Brill, De-Raffele, Manno, Mountainview, Musi, Paramount, Silk City, Sterling, Swingle—and perhaps a few obscure builders I've never heard of. They all have their stories. And they all made a significant contribution to a pure American art form.

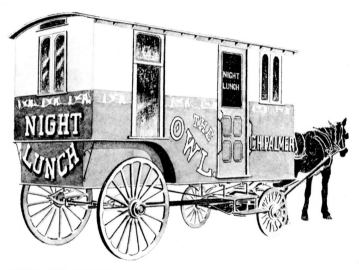

THE OWL NIGHT LUNCH
Watercolor, 7 1/4 × 10 1/2″, 1977
Collection of the artist

This watercolor was painted from an early ad for Palmer lunch wagons. The wagons served a night trade, and business was conducted around the clock. All twenty-four hours. Many wagons and diners to follow were called "Night Owls," and the bird of night became a popular theme.

143

Diner Paintings and their Sites